Jonas Lie

(1880–1940)

January 12–February 25, 2006

William H. Gerdts

Carol Lowrey

Spanierman Gallery, LLC

www.spanierman.com

45 East 58th Street New York, NY 10022 Tel (212) 832-0208 Fax (212) 832-8114
ginagreer@spanierman.com Monday through Saturday, 9:30 to 5:30

Cover: *Amber Light (Amberjack II)* (detail of Cat. 32)

Published in the United States of America in 2005 by
Spanierman Gallery, LLC, 45 East 58th Street, New York, NY 10022.

Library of Congress Control Number: 2005937328

ISBN 0-945936-75-3

Design: Marcus Ratliff Inc.
Composition: Amy Pyle
Photography: Roz Akin
Color imaging: Center Page Inc.
Lithography: Meridian Printing

Contents

Foreword

IN HIS own day, Jonas Lie was widely acclaimed, but time can have a funny habit of chipping away at fame. For the last sixty-five years or so he has been buried under the detritus of obscurity. We have organized this exhibition of Lie's work and produced this accompanying catalogue to both unbury and to praise him.

I have always felt that Lie (1888–1940) belonged in the pantheon of extraordinary American artists of the twentieth century, alongside George Wesley Bellows (1882–1925), Rockwell Kent (1882–1971), and others. Therefore, the gallery began gathering works by Lie with a plan to eventually having an exhibition of his work and producing a catalogue.

This plan was continually waylaid because as soon as the gallery acquired a work by Lie, there was always a client who bought a work by Lie. Finally, we managed to find enough work by Lie to accommodate our original plan. I hope you will enjoy this exhibition as much as I will. It has been a labor of love.

IRA SPANIERMAN

Acknowledgments

IT HAS taken a small group of dedicated individuals on both sides of the Atlantic to make Ira's dream of a Jonas Lie show a reality. We have been very fortunate to have the cooperation of the artist's family in Norway, especially his granddaughters Inga C. Thommessen and Ellen Thommessen von der Lippe. Their personal records and ephemera provided wonderful background and introduced us to Lie scholar Dina Tolfsby, curator of the Norwegian American Collection at the National Library in Oslo. Ms. Tolfsby and Bendik Rugaas, counselor for cultural affairs at the Royal Norwegian Embassy in Washington, D.C., have been extremely supportive, as have numerous Norwegian "friends of Lie."

Stateside, we are grateful to many of the institutions, private collectors, and dealers who own Lie's work. Not only do they share our passion, but they have generously loaned paintings to the exhibition and provided images for the catalogue. A special thank you is due to Caroline Welsh and the Adirondack Museum, Blue Mountain Lake, New York, for their enthusiastic participation.

For this catalogue Dr. William Gerdts distilled an eventful artist's life concisely and eloquently, and Dr. Carol Lowrey investigated Lie's influences and themes to present the first in-depth look at this artist. Designer Amy Pyle applied her expertise once again to create a worthy publication to showcase Lie's vibrant art.

My gallery colleagues are to be applauded for their commitment to this project. In the truest sense of teamwork, Dr. Lisa Peters was a valuable editor; research associate Kristen Wenger secured images and factchecked; archivist Jodi Spector organized and maintained records for every work; and photographer Roz Akin's own talents are evident in the stunning color plates in this book. Lastly, I must express my gratitude to our registrars Bill Fiddler and David Major, and the arthandlers, Nino DeLeon, Luis Garay, and Ken Stevens, who patiently transported each of these exceptional works.

GINA GREER

Introduction

IRA SPANIERMAN and I have been enthusiastically involved in numerous projects over the past fifteen years of our association. These have taken a variety of forms, including my participation in a number of the catalogue raisonnés that Ira sponsors, such as those of the artists John Twachtman, Theodore Robinson, and Willard Metcalf, and in numerous exhibitions. Some of these, such as the recent show of *The Poetic Vision: American Tonalism* and *Natural Habitat: Contemporary Artists of North America*, have consisted of works related to particular artistic themes or movements, involving numerous artists; others, such as exhibitions of the work of Frank Benson, Metcalf, Joseph Raphael, and Twachtman have been devoted to studies of individual important American painters. We have also, of course, discussed artists who had achieved considerable acclaim in their own time, but have, since their deaths, declined in either or both public and scholarly appreciation, and the possibilities of resurrecting their art and their reputation to their rightful places. For both of us, one of the painters most deserving of such a "renaissance" has been Jonas Lie. He was a major artist in his own day. His paintings were not only popular among collectors, but were also lauded by the critics. He was an important figure in the American art world, too. For a while, he was the president of the National Academy of Design. Furthermore, Lie appears to have been a fairly prolific painter, and in recent years his pictures have appeared singly in shows held in commercial galleries and especially at auction, where viewers seem regularly to have been attracted to them, both for the power of his art and its individuality—simply speaking, they "look like" the work of Jonas Lie, and no other artist. Indeed, perhaps that is the reason there has not been a more comprehensive show of his achievement until now, that is, they do not quite fit into the prevailing modes used to categorize art, "Naturalism," "Impressionism," "Expressionism," "Modernism," or many of the other artistic classifications so dear to the art historian.

Although ambiguous and equivocal, one can, I think, refer to Lie as a "Big Man," a painter of works that project a sense of largeness, not only in the distinctiveness of his often very contrasting colors—the sense of substantial forms, and a recognition of the power behind his application of paint on a large and dramatic scale—but a largeness of vision also. The other artist who most comes to my mind when I think about Lie's art and his achievement is George Bellows. Perhaps had Bellows not come under the double influences of the Maratta Color System and the compositional theories of Dynamic Symmetry, which together led his later art off into often quite fascinating accomplishments—though very different from his work of the first decade of the twentieth century—he might, in his landscape paintings, have produced pictures bearing striking similarities to those of Jonas Lie. As it is, Lie's work stands pretty much alone—the best of it startling in its combination of beauty and power.

WILLIAM H. GERDTS

Jonas Lie (1880–1940)

WILLIAM H. GERDTS

JONAS LIE was surely the finest and most significant Norwegian-born artist to live and work in the United States. Indeed, the Scandinavian contribution to the development of painting in America has been greatly overlooked with a few exceptions: the Swedish artist, Gustavus Hesselius in the eighteenth century, Danish-born Emil Carlsen at the end of the nineteenth, and, along with Lie in the early twentieth century: B. J. O. Nordfelt, Henry Mattson, John F. Carlson, and Carl Sprinchorn, all Swedish-born. This lacuna is due, in part at least, to the fact that, with those exceptions, the majority of Scandinavian painters settled in the Midwest and their artistic achievements have been subsumed into regional identification; Lie, who first settled in Plainfield, New Jersey, and then was active for the rest of his career in New York City, early on achieved national recognition and status. Ironically, however, despite his several return trips back to his native land, and as Norwegian-born, becoming a Knight of the Order of St. Olav in 1932, he remains almost totally unknown and unrepresented in his native Norway. On one of visits back to his native land, in 1934, he visited the expatriate American Impressionist William Singer and his wife, who lived part of each year in Olden, resulting in the donation by the Singers that year of a work by Lie to the Washington County Museum of Fine Arts in Hagerstown, Maryland, which they had founded in 1929.

Jonas Lie was born in Moss, Norway, on 29 April 1880, the son of a Norwegian father Sverre Lie, a civil engineer, and an American mother Helen Augusta Steele, from Hartford, Connecticut; he was one of four siblings, the others all female. Sverre Lie was a member of a family distinguished as writers, musicians, and painters. Lie grew up in Christiania (now Oslo), but after his father died in 1892, Lie had some initial drawing instruction from his cousin, Christian Skredsvig, one of Norway's most prominent artists of the late nineteenth century and then spent a year in Paris with his uncle and namesake, one of Norway's most renowned writers, Jonas Lauritz Edemil Lie. Though there only a year, the young man entered a world of distinguished cultural expatriates from Norway, including the composer

Edvard Grieg and the playwright Hendrik Ibsen. His uncle also enabled him to attend a small, private art school and took him on visits to the Louvre. Lie came to America in 1893, joining his mother and sister, the family staying with his aunt who ran a boarding house in New York, while the young Jonas Lie studied art in New York at Felix Adler's Ethical Culture School (then called The Workingmen's School) with (Miss) Dewing Woodward, who took him to Provincetown on Cape Cod in 1896, where he painted out of doors for the first time. During this same time, the family moved to Plainfield, New Jersey, after his aunt's death. Following his graduation in 1897 from the School, Lie worked as a designer of calico patterns at the Manchester Cotton Mills on Duane Street, New York. He held that position for nine years until the shop turned from cotton to wool and Lie's services were no longer needed. He is said to have taken night classes in New York at both the National Academy of Design and after that at the Art Students League, though the records of the academy do not list Lie as a student there; he also studied during one winter at the Cooper Union.

Lie rented a studio in New York, sketching at Rockaway Beach, though he remained based in Plainfield. Lie's earliest known painting is the very sketchy *After the Concert*, now in the collection of the Spencer Museum of Art at the University of Kansas, Lawrence, which was painted in 1900. The artist began exhibiting at the National Academy in 1901. He was identified from the start as a landscape painter and, judging by the few known pictures located from this period and from the titles of the works he exhibited there as well as in in Philadelphia and Chicago (*A Gray Day*; *Reflections*; *Early Snow*), it would seem that he was attracted early in his career to the popular Tonalist aesthetic of the period, with an emphasis on seasonal and, particularly, winter scenes. Lie's professional identification within the New York art world began with his involvement in the Country Sketch Club of New York, with which he began show in 1901, along with Alfred Maurer and Maurice Sterne. Led by Van Dearing Perrine, the club had been founded in 1897 to further the involvement of the students at the school of the National Academy of Design in outdoor painting. The artists' activities were first based in Ridgefield, New Jersey, though by 1899 the club had its headquarters in the New York studio shared by Perrine and Sterne. Lie continued to exhibit with the Club through 1906. Lie felt especially honored when *A Winter Idyll*, shown at the Pennsylvania Academy of the Fine Arts in 1903, was

purchased by William Merritt Chase. In 1905 Lie had his initial one-artist exhibition at the New Gallery, run by Mrs. Mary Bacon Ford.

In 1906 Lie made his first trip back to Norway. By the time of his return to Plainfield, his mother had died and his sisters had moved to California. Without familial responsibilities, Lie was able to paint full-time, having already taken a studio in the Babcock Building in the center of Plainfield in 1904, a structure recently rebuilt in 1903 after a disastrous fire the previous year. There he both worked and took pupils. He also held an exhibition in his studio, where he successfully sold a number of small paintings. While the Babcock Building was also home to the Masonic Lodge in Plainfield, it must have been well suited for artists' studios, for much later, in 1936, it began to house the Du Cret School of Art where Lie, along with John Carlson, Yasuo Kuniyoshi, and William Zorach taught. The geographic identities portrayed in Tonalist pictures are notoriously difficult to locate, but some of these, at least were painted in New Jersey where he continued to reside through 1909. In 1905 he showed *Summit Road* at the academy, a reference presumably to the community of Summit, not far from Plainfield, and that same year showed *The Road to Coytesville*, a view of a town near Ridgefield and Fort Lee, New Jersey, at the Pennsylvania Academy. That year also, Lie had another one-artist exhibition of thirty-four paintings at the Pratt Institute. Altogether Lie enjoyed fifty-seven one-man shows during his lifetime.

In 1906 Lie visited Paris, on his return trip back from Norway, and began to be influenced by the work of the French Impressionists. In 1909 he returned to Europe, spending eighteen months abroad, including a year and a half back in his native Norway, his longest stay there. He first painted in Oslo, but then spent the winter painting in Lillehammer, while exhibiting in Oslo (then still Christiania) for the first time. Lillehammer, to the North of Oslo, had been a favorite painting ground of the Norwegian Impressionist, Frits Thaulow, whom both Lie and his critics acknowledged as an influence on his own painting. After leaving Norway, Lie spent three months in Paris, creating landscapes on the Seine and visiting the salon of Leo and Gertrude Stein. Seeing the work of Henri Matisse there, Lie went on to meet the great French modernist and saw the work of the Matisse class. It was on this trip, and after his return to the United States in 1910, that Lie began his artistic maturation, both thematically, in his attention to more rugged forest subjects, mountain views, and coastal scenery, and formally, in the

vigorous brushwork, intense and interpretive coloration, strong chromatic contrasts, and an overwhelming concern for light, an aesthetic that has a counterpart in the figurative work of the contemporaneous Ashcan School and the landscapes of the premier Ashcan School painter George Bellows, while his inland winter scenes correspond to the aesthetic of Edward Redfield, the best-known among the artists then active in New Hope, Pennsylvania.

Lie had his third one-artist show in New York in November 1910, at the Madison Galleries run by Mrs. Clara Davidge and the painter Henry Fitch Taylor, whom she later married. At the time, critics noted the change in the direction of Lie's art, perceptively acknowledging the relationship with Thaulow. They were even more impressed when he showed his work at the Folsom Galleries in New York in 1911 and again in 1912, where critics discerned the influence of the urban realists in his pictures of wharves, bridges, and the waterfront. Lie remained most noted for his pictures of water scenes with boats, painted in a broad and direct manner; forests, especially of birch trees, constitute probably Lie's second most often realized subject. Essentially a realist, Lie remained an ardent advocate of academic standards and an opponent of more progressive aesthetics that emerged during his lifetime.

Lie now relocated to New York City, first living on Washington Square South in a boarding house owned and run by Miss Davidge, a major patron and supporter of contemporary art and artists, who made 62 Washington Square South the home to many of the leading artists of the day; Ivan Olinsky and William Starkweather were living there at the time. Davidge herself moved to Staten Island in 1913, the year that Lie relocated north, first to the Holbein Studio Building at 154 West 55th Street, where he also taught, and then to 2 East 81st Street, while in 1918, he took a studio in the Sherwood Studio Building at 58 West 57th Street. Lie participated in the famous Armory Show, held in New York in March of 1913, with five paintings, including *The Black Teapot*, now in the Everson Museum of Art, Syracuse, New York. Still life painting, in fact, marks another theme for which Lie is most noted. His *Nasturtiums and Asters* appeared in the Anglo-American Exhibition held in London in 1914; his other entry in that show was a cityscape of *New York*. Urban scenes, in fact, were not rare in Lie's oeuvre, though they appear almost always to involve a river perspective. *New York* is not unique. The North Carolina Museum of Art, Raleigh, has in its collection Lie's painting of the *Woolworth Building at Night*. The Cornell Fine Arts Museum, Rollins College, Winter Park,

Florida, owns his *Dusk on Lower Broadway*, probably painted in 1911. The Memorial Art Gallery of the University of Rochester, New York, has his Brooklyn Bridge painting, *Morning on the River*. Other unlocated works include *The City Ice-Bound* as well as his *Washington Square* and *Broadway, New York*, the last two of which are rare, internal views of the city.

Likewise, while some of his coastal paintings, especially, include subsidiary figures, figure paintings themselves are extremely uncommon in his oeuvre, though he did paint such works as his *Children Bathing*, now in the Arnot Art Gallery, Elmira, New York; even here, however, the picture is primarily a somewhat intimate landscape of a woodland stream with a group of summarily painted bathing children. Another now unlocated work that he displayed at the Armory Show was *The Quarry*, a picture that presaged Lie's most celebrated achievement, for in 1913, the year of that show, Lie traveled to Panama, subsidized by a Plainfield neighbor. He had already seen the graphic images created there by Joseph Pennell, but was motivated by the imperative to document the vast engineering project in color. There, he created his most famous paintings, producing about thirty-five sketches that he developed into about twenty-two oils of the excavation of the Panama Canal. The two other artists associated with this, the most spectacular engineering project of the time, were Pennell, who had preceded him, and the painter, Alson Clark, who was working there at the same time as Lie. Lie spent three months in Panama, as the guest of General George W. Goethals, the engineer in charge of this project. It may be that Lie's attraction to this subject was heightened by the knowledge that his father had taken part in an engineering project not totally dissimilar, the building of the Park Avenue Tunnel of the New York, New Haven & Hartford Railroad leading to Grand Central Station. Lie's pictures depict the tremendous steel works and document the way that huge masses of earth were being moved to create the waterway. Altogether, he succeeded in achieving his goal of interpreting the epic quality of the both the concept and the labor of construction, as well as creating a visual record of the great task. The paintings brought the artist tremendous renown when they were first exhibited at M. Knoedler & Company in New York at the very end of December 1913. They were subsequently shown at the Pennsylvania Academy, the Detroit Institute of Arts, and the Art Institute of Chicago. Critics were ecstatic about the pictures, labeling them "Homeric" and "heroic." Though the artist's hopes to keep the series together went unrealized, the Metropolitan

Museum of Art bought *The Conquerors* and the Detroit Institute of Arts purchased *Culebra Cut* out of the exhibition that year. *The Gates of Pedro Miguel* won Lie a silver medal at the Panama-Pacific International Exposition, held in San Francisco in 1915. And in 1929, twelve of the series were donated to the United States Military Academy in West Point, New York.

In 1917, on his way to visit San Francisco from where he would spend the summer in Carmel on the Monterey Peninsula, he was commissioned to paint a series of eight pictures of the Utah Copper Mines in Bingham Canyon, Utah, recommended by his friend, the painter Irving Wiles, and surely inspired by his success with the pictures of the Panama Canal construction. The Copper Mine series was exhibited at the Knoedler Galleries in New York in November of 1917. He was made an associate member of the National Academy in 1912, winning the Hallgarten prize in 1914 for *Afterglow*, a painting of New York City's highrise buildings on the waterfront, as seen from the river, now in the collection of the Art Institute of Chicago. In 1919 he led a protest against the jury system as then in place at the academy, calling for a reform in the jury selection as well as limiting the time allowed for an associate to be elected to full academician, and allowing for the inclusion in the academy annuals of watercolors and works in black and white. Lie was supported by such distinguished fellow artists as Bellows, Pennell, Gifford Beal, Robert Henri, and the sculptors, Paul Manship and Alexander Calder. This group went on to establish a separate organization in 1919, the Society of American Painters, Sculptors, and Gravers, with Childe Hassam as president and Lie as secretary. The society held its first exhibition in 1919 and then changed its name to the New Society of Artists, when it held its second annual show in 1920, which traveled to the Art Institute of Chicago. The critical reviews of these shows were overwhelmingly favorable, noting still their academic foundation but discerning improvement over the National Academy's annual exhibitions. Lie, however, remained a member of the academy, helping to initiate changes in the organization's policies; he became a full academician in 1925, winning the Carnegie Prize in the academy's annual exhibition in 1925 with *The Cloud*, a painting of sailing vessels seen through a grove of birch trees. In the decade following, he was the president of the academy from 1934 to 1939, winning the Saltus Medal in 1936 and the Obrig Prize in 1937. Lie capitalized on his birthright by participating in Norwegian-American shows in Chicago, the center for the exhibition of Scandinavian-American artists and home to many of

them, winning prizes in 1925 and 1927. He was also a sponsor and founder of the Norwegian Arts and Crafts Club in 1939. A fair number of Norwegian subject paintings exist within his oeuvre, both landscapes such as *A Fjord*, in a private collection in Hartford, and several urban scenes in Oslo, which have appeared on the New York art market.

Lie visited and painted in a number of the major American art colonies of his time, further confirming his mainstream position in the art world. He exhibited paintings entitled *Old Lyme* in both San Francisco and Los Angeles in 1917, rendered such scenes as *A View from Banner Hill, East Gloucester*, a subject undertaken by many of his contemporaries who formed a transient art colony there, and was especially associated with Woodstock, in New York State.

In 1922 Lie purchased Howland Cottage in Saranac Lake in the Adirondacks, so that his wife, the former Inga Sontum, a Norwegian ballet dancer, could receive treatment for tuberculosis at the Trudeau Sanatarium. It was there that he painted many of his winter landscapes and mountain subjects, reminiscent of the scenery of Norway; four of his early Adirondack pictures were included in a one-artist show held at the Memorial Art Gallery in October of 1924. After Inga's death in 1926, Lie concentrated on harbor scenes and seascapes, motifs that he found along the North Atlantic coast from New England to Canada, painting on Cape Ann, Massachusetts, on the coast of Maine, in Nova Scotia, and in Europe on both sides of the English Channel. However, he returned to the Adirondacks in February of 1930, having agreed to paint a series of pictures of Lake Kora and the Francis P. Garvan camp there; seven of the series was shown in his exhibition at the Macbeth Galleries, New York, in January of 1931. In 1930, also, Lie donated a ten-foot-long mural landscape to All Souls Unitarian Church in Plainfield, as a tribute to his deceased wife; the citizens of the city had already acquired his painting, *The Birches*, painted in Woodstock, which hangs in the town's City Hall. In his later years, Lie himself became increasingly conservative both in his artistic and his political views. This lead to a conflict in 1932 when John Sloan, then president of New York's Art Students League, invited the German artist George Grosz to teach at the league. Lie, as one of the directors, opposed Grosz's appointment, resenting his modernist political caricatures. The result was a withdrawal of the invitation to Grosz and the resignation both of Sloan and Lie, though the latter's resignation was not accepted by the board of the league. Yet Lie, while insisting on the need

for thorough academic art training, was not totally opposed to modernist ideas, especially in regard to colorist experimentation and allowed that exaggeration, distortion, and elimination of form was permissible, when an artist could achieve a greater amount of the spirit of the subject he was producing. And during his tenure as president of the National Academy, Lie was involved in a number of controversies, championing a more liberal teaching faculty for the academy school, opening up the annual shows to more invited artists, and reducing the number of jurors whose approval was required for exhibition.

Although during the second decade of the century Lie was associated with the Madison, Folsom, and Knoedler Galleries, he had his first show with the Macbeth Galleries in March of 1921 and with the Milch Gallery, New York, in April of 1925. He again showed at Macbeth in 1926 and continued participating in annual exhibitions there through 1934. However, he was not to have another one-artist show until 1938, when he exhibited his "Light and Air" paintings at the Grand Central Art Galleries in April. Under pressure in organizing an art exhibition for the 1939 New York World's Fair, Lie's health began to fail, and he died in January of 1940; fittingly, he was buried at Hillside Cemetery in Plainfield. A memorial exhibition of his work was held in May of 1940 at the Grand Central Art Galleries, consisting of many of his recent works painted the previous summer in Maine and on Canada's Gaspé Peninsula.

On his death Lie was the subject of numerous laudatory obituaries, while during his lifetime articles by many of the leading art writers of the period acknowledging his artistic achievements appeared in just about all the art magazines of the 1910s, 1920s, and 1930s. Yet, interest in Lie's work after 1940 simply evaporated, undoubtedly due to the more conservative temperament that he displayed in his art, and the rise of abstraction. A show of his paintings appeared at the Philbrook Art Center, Tulsa, Oklahoma (now Philbrook Museum of Art), in the spring of 1942, but after that, the only exhibition of his work known consisted of a display of his Adirondack Paintings, held at the Adirondack Museum, Blue Mountain Lake, New York, in June of 1971, at least part of which went on to the State University College at Plattsburgh, New York, the following January. In May 1971 Joseph Masheck discussed Lie briefly in an article on the visual images of the Panama Canal in *Artforum*, though his principle subject there were the etchings of Joseph Pennell.

Otherwise, interest in Lie remained dormant until some years ago when I interested Ruth Pasquine, a graduate student at the City University of New York, in pursuing a dissertation on Lie. Ruth amassed a wonderful archive of material on Lie, but concluded that she had a greater compelling interest in the more progressive art of the twentieth century and abandoned the Lie project. However, Ruth generously turned over to me all the material she had gathered, and much of what is written in the present essay and catalogue is derived from Dr. Pasquine's research. Still, Jonas Lie and his art remain in need of a comprehensive study to fully reveal the breadth of his artistic achievement.

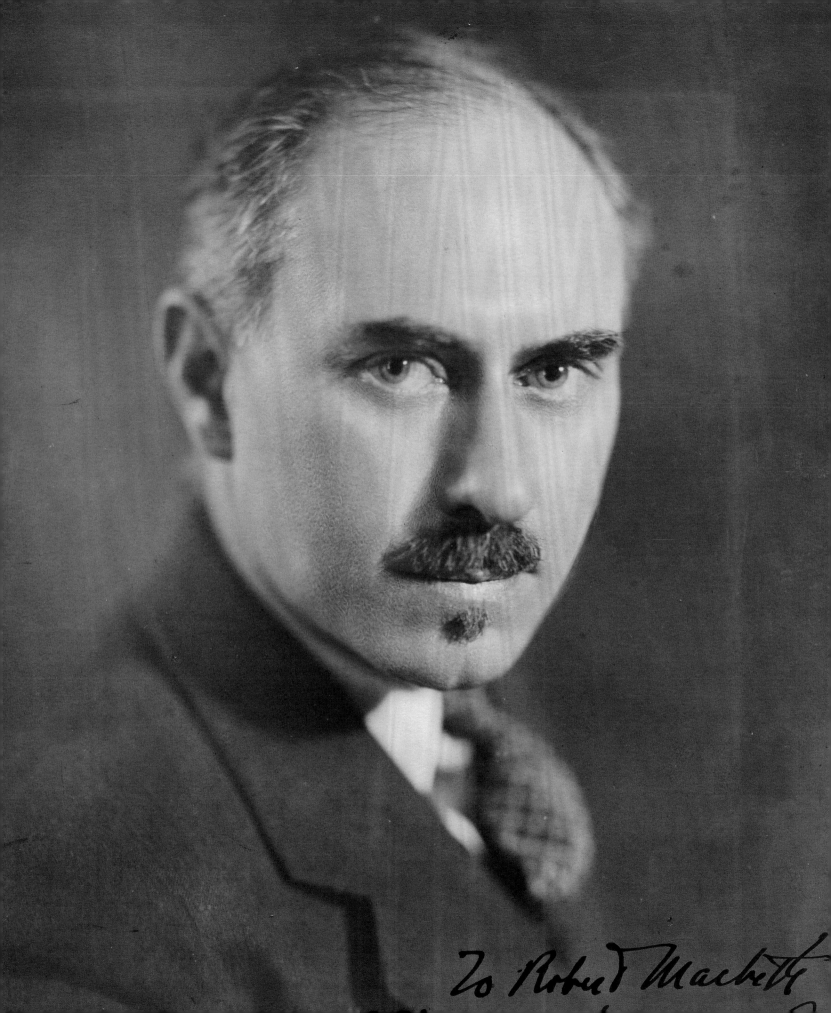

To Robert Machett

Jonas Lie (1880–1940): Painter-Poet of His Era

CAROL LOWREY

What romance is to a narrative, what poetry is to a thought,
Lie's painting is to the realism of the land he paints. Inspired by what
he sees, Lie brings to his work the soul of the modern artist
expressed with the sanity of the thinker and the philosopher.
—Rose V. S. Berry (1925)[1]

Art is an individual expression and must be
the result of individual convictions.
—Jonas Lie (1927)[2]

I do not attempt voluntarily to symbolize nature,
but in portraying nature to impart to my work a suggestion
of that which is within, and that which is beyond.
—Jonas Lie (1934)[3]

IN JANUARY of 1901, while still a young art student, Jonas Lie made his professional debut at the National Academy of Design in New York, where his *A Gray Day*, a moody, tonal landscape painted at Rockaway Beach, was selected for inclusion in that year's annual.[4] Two months later, he contributed five oils to an exhibition of work by the County Sketch Club, held at the Art Institute of Chicago, and in 1903, his canvas, *A Winter Idyll* (location unknown), was acquired by the celebrated painter William Merritt Chase from the annual exhibition of the Pennsylvania Academy of the Fine Arts in Philadelphia. Lie's star was clearly on the rise; he went on to receive a silver medal at the Louisiana Purchase Exposition in 1904, and he had solo shows at the New Gallery in New York and at the Pratt Institute in Brooklyn in 1905.

Fig. 1.
Portrait of Jonas Lie,
ca. 1900, photograph,
Macbeth Gallery Records,
Archives of American Art,
Smithsonian Institution,
Washington, D.C.,
reel 440, fr. 0128.

In 1906, having left his job at a textile mill, Lie turned his full attention to painting. His gamble that he could make it in the competitive New York art world paid off; indeed, as early as 1907, the critic, James Huneker, had informed his readers that there was something special about Lie's art, referring to him as a "painter of poetic temperament and individual vision,"[5] while a writer for *Craftsman* praised his ability to translate the moods of nature into paint.[6] In 1912, by which time Lie was incorporating urban themes into his repertoire of subjects and had abandoned his Tonalist approach in favor of a robust style in which he fused aspects of Realism and Impressionism, he was identified by a penman for *Current Literature* as "one of the most promising of the younger artists now working in New York," expressing an artistic vision shaped by his American milieu and training and by his Scandinavian background.[7]

Lie attracted sustained critical support through the mid- to late 1910s and well into the early 1930s, a period when he enjoyed numerous solo exhibitions throughout the country, was inducted into the most venerable art societies of his day, and joined the stable of artists associated with the prestigious Macbeth Gallery in New York (Fig. 1). Commentators such as J. Nilson Laurvik referred to him as one of the most "virile" painters working in the United States,[8] and Lorinda Munson Bryant identified him as among a younger generation of American artists who struck an "original note" in his "manner of treatment"—an artist armed with a "message and a vision that are true and noble."[9] Articles by the likes of Rose V. S. Berry, Christian Brinton, and Edgar Cahill also contributed to Lie's renown, to the extent that in 1934—the year he assumed the presidency of the National Academy of Design—he was deemed "one of the best-known landscape painters in America."[10]

In the wake of Lie's death in 1940, Peyton Boswell of *Art Digest* summed up his oeuvre as reflecting the "'front-yard' of the American scene—picturesque seaboard villages, snug fishing harbors, silvery birches mirrored in still, blue-green water, peaceful landscapes and other aspects of beauty in America."[11] His comments aptly describe the work in this exhibition—a collection of paintings that, while serving to bring Lie's accomplishments to the attention of contemporary audiences, also underscores his enduring concern for an art based on personal experience, subjective response, and traditional ideals of beauty and fine craftsmanship.

THE EARLY YEARS

Jonas Lie initiated his artistic training in his native Norway, where, in 1892, he spent three months studying in the studio of his cousin, the artist Christian Skredsvig, learning the rudiments of landscape painting. Later that year, while residing in Paris with his famous uncle and namesake, the novelist Jonas Lauritz Edemil Lie (1833–1908), he took drawing lessons during the evening and visited the Louvre and Luxembourg museums by day. On moving to New York in 1893, Lie enrolled at Felix Adler's Ethical Culture School and through this means came into contact with the painter Dewing Woodward, an instructor in the school's Department of Fine Arts. Miss Woodward later recalled that although Lie excelled in music, he was an even better artist whose work demonstrated an inherent feeling for form and color.[12] At Woodward's suggestion, Lie attended her night classes in life drawing for a period of four years, and in 1896, in conjunction with his studies at the Ethical Culture School, he attended Woodward's summer classes in Provincetown, Massachusetts, experimenting with the techniques of outdoor painting. Most articles and biographical accounts of Lie written during and after his lifetime indicate that he went on to attend evening classes at the National Academy of Design about 1900, although this author has discovered that he is not listed in any of that institution's student registers.[13] Lie's name does crop up in the records of the Art Students League, where he studied during 1901–1902. He also spent a winter at the Cooper Union School, an experience that he found "most uninteresting."[14]

Lie's formal training aided him in developing his proficiency in drawing and composition, while visits to the annuals of the National Academy of Design and the Society of American Artists enhanced his familiarity with Tonalism and Impressionism, the dominant trends in American art at the turn of the twentieth century. However, the most salient influence on Lie during these formative years appears to have been his association with the Country Sketch Club, established in 1897 by the painter Van Dearing Perrine and a group of his fellow students from the National Academy of Design in response to the lack of outdoor classes in the academy curriculum.[15] The club flourished until 1912 and attracted painters such as G. Glenn Newell, Charles Hawthorne, Maurice Sterne, Walter Farndon, Ernest Roth, and William Glackens. It was headquartered in a loft on Broadway and

Thirteenth Street in New York, where members painted from the model, and in a "shack" in the village of Ridgefield, New Jersey (the so-called "Barbizon of the Palisades"), where Lie and his cohorts spent their weekends portraying the area's woods and meadowlands as well as the local waterfront.[16]

Lie's affiliation with the County Sketch Club began about 1900 and lasted until 1906, when he began to paint full-time. In a later interview with De Witt McClellan Lockman, he remarked upon the impact of his association with the organization, calling it "the influence that brought about a much closer relationship with nature," and stating: "In 1900 we painted tone things, sort of dark Whistlerian things, toning our canvas"—a comment that reveals the impact of both Tonalism and the muted color harmonies of James McNeill Whistler on his developing style.[17] The aforementioned Cahill noted that Lie's work from this period consisted primarily of "paintings of snowy hillsides, windswept trees, brooding sky and water, grey-white things of somber beauty and repressed power" a description that would apply to works such as *Birches* (Cat. 1), from 1903 and a slightly later piece, *Old Covered Bridge* (Cat. 10), both of which demonstrate the low-keyed palette, fluent handling, and engagement with intimate settings that characterized Lie's developing aesthetic. As observed by Brinton, these early oils, "showed power and conveyed a sense of the elemental spirit of nature and the natural scene."[18]

While Lie's tonal works dominated much of his work from the early 1900s, the artist was soon on his way to discovering the emotive power of color, as apparent in the fresh reds and oranges appearing in his striking rendering of the flooded streets of Plainfield, New Jersey (Cat. 2). This interest was heightened after his visit to Paris in 1906, where he had the opportunity to see paintings by the French Impressionist Claude Monet, who, to quote Lie, "cleaned the palette of the [whole] world."[19] In the ensuing years, Lie began to incorporate brighter hues into his oils and his work took on what one commentator referred to as "a greater breadth and clarity of vision."[20] Changes in Lie's chromaticism are certainly evident in spontaneous, Impressionist-inspired vignettes such as *Landscape* (Cat. 4) and in the more tightly rendered *Quiet Town* (Cat. 3), in which dull earth tones and somber grays are offset by fresh greens, bright red, and blue. The latter work was executed during the artist's eighteen-month sojourn in his native Norway during 1909–10. As well as visiting Oslo and Lillehammer, Lie spent part of his time in Gudbrandsdalen, a lush and very beautiful valley in Norway's interior countryside, where he painted

views of his immediate environment. The rustic dwellings and timber-frame farm-houses in *Quiet Town* obviously struck a chord with Lie in terms of his Nordic heritage, for he went on decorate interiors for several of his patrons, such as Malcolm D. Whitman of New York, for whom he designed a "splendid Viking room."[21] He also constructed a bungalow on Watchung Mountain, near Plainfield, that, in terms of design and décor, is said to have resembled a "typical Norwegian *bjelkestue.*"[22]

The concern for color that emerged during Lie's early career was given further impetus by his exposure to the work of the Post-Impressionist painter Paul Gauguin and that of the "revolutionary" Fauvist Henri Matisse, whose aesthetic proclivities

Fig. 2. Jonas Lie, *The Black Teapot*, 1911, oil on canvas, 35 × 42 in., Everson Museum of Art, Syracuse, New York, Museum purchase from the artist.

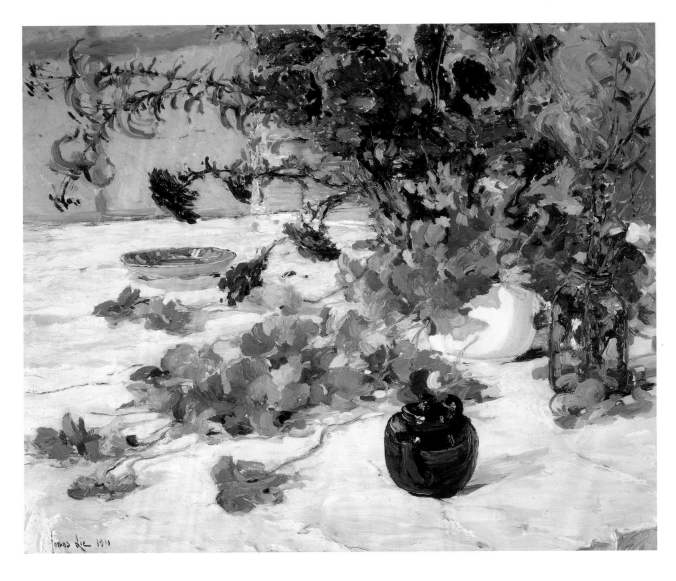

revolved around the use of simplified shapes, structured designs, bold colors applied in an arbitrary, non-naturalistic manner, and a desire to evoke the essence of a subject rather than merely describing it.[23] Indeed, during his trip to Norway in 1909–10, Lie spent three months in Paris; there, in addition to painting along the Seine, he was fortunate enough to have been invited to visit the salon of the American expatriate art collectors Gertrude and Leo Stein at 27, rue de Fleurus, where he saw examples of cutting-edge art, including paintings by Matisse. He even met Matisse in his studio and observed a class at the recently established Académie Matisse. During his Parisian sojourn, Lie's visits to commercial galleries provided him with additional opportunities to see examples of avant-garde painting firsthand; he later claimed that Gauguin had made "a very great impression" on him,[24] and in his 1927 interview with Lockman, he reiterated his liking for the work of Modernist painters such as Gauguin and Matisse.[25]

That Lie responded to the chromatic innovations of contemporary French painting soon after his return is apparent in his joyful still life, *The Black Teapot* (Fig. 2), in which the artist's vibrant color contrasts imbue the image with a sparkling vitality. This painting—a splendid affirmation of Lie's early link with Modernism—was among the five oils he contributed to the legendary Armory Show of 1913, an event that introduced New York art audiences to the work of Matisse, Paul Cézanne, Vincent van Gogh, and other members of the European and American vanguard.[26] In the ensuing years, the creative use of color would assume a major role in Lie's art, as he melded this with his penchant for representational realism and the decorative use of form to produce a truly subjective vision of nature.

LIE AND THE MODERN URBAN AND
INDUSTRIALIZED LANDSCAPE

[Lie] likes to work, likes men who work, and, above all, loves to paint workers.
—*Arts and Decoration* (1919)[27]

Lie has read beauty into industry, into modern cities,
into the tumult and vibrant disorder of today.
—Edgar Cahill (1923)[28]

IN 1910 Lie left Plainfield and returned to New York, moving into a boarding house at 62 Washington Square South that was operated by the art patron Clara Davidge. He later told Lockman that it was "at that time my interest started in buildings, bridges and city subjects."[29] Lie's excursions into this genre of subject matter no doubt stemmed from his awareness of the gritty, down-to-earth urban imagery of New York Realists such as Robert Henri and William Glackens, and with the more lyrical cityscapes of Impressionists such as Childe Hassam. The artist's affinity for images relating to labor, toil, and industry also had a measure of personal resonance, for on graduating from the Ethical Culture School, Lie spent nine years working as a designer of textile patterns at Manchester Mills, a cotton factory in Manhattan, an experience that gave him direct exposure to the man-made environment.

Like so many artists of his generation, Lie drew frequent inspiration from the "new New York," creating dynamic representations of the city's bustling waterfront, soaring architecture, and spectacular bridges, evident in works such as *Path of Gold* (Fig. 3), a view of the East River looking towards the Brooklyn Bridge. At the same time that he was exploring the modern metropolis, he also investigated the pictorial potential of the small manufacturing centers scattered throughout the northeastern United States. Inspired by a locale in New England, Pennsylvania, or New Jersey, *American Factory Town, Winter* (Cat. 8) can be interpreted as an optimistic reminder that the early twentieth century marked a period of tremendous growth in the industrial sector, spurred on by new developments in

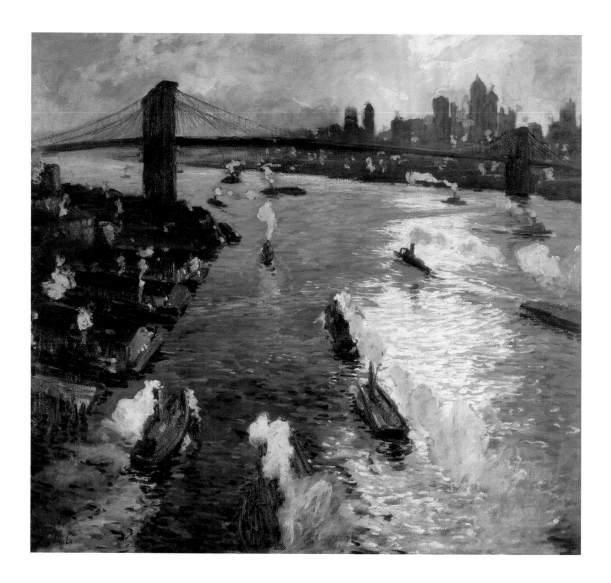

Fig. 3. Jonas Lie, *Path of Gold*, ca. 1915, oil on canvas, 34 × 36 in., High Museum of Art, Atlanta, Georgia, J. J. Haverty Collection.

technology and an increasing demand for goods and products, and this expansion was felt in both cities, as well as in smaller locales. Lie's carefully constructed townscape features plumes of smoke drifting lazily into the distant sky, their dark shapes forming a contrast with the sparkling sunshine glancing off the brick façades and snow-covered rooftops in the foreground; indeed, in *American Factory Town,* Lie combines the straightforward Realism espoused by the Henri circle with the light and coloristic concerns of Impressionism—a methodology that caught the eye of critics such as Christian Brinton, who declared: "He freely proclaims himself a realist, with leaning toward free pictorial impressionism, and it is from direct contact with nature that his chief stimulus derives."[30]

Lie's involvement with themes relating to contemporary toil and labor, and his ability to conjoin observed reality with personal emotion, are likewise apparent in his depictions of dock and shipyard employees, ice harvesters, and other working types, and in his remarkable Panama Canal series. His first exposure to this grand project came in the form of a motion picture on the canal, which he viewed in the early months of 1913. A few days days later, enthralled by what he saw, Lie traveled to the Panama Canal Zone (his trip having been funded by a patron, Charles W. McCutchen), spending three months as a guest of General George W. Goethals, the engineer in charge of the project.[31] Of course, Lie was not the first American artist drawn to the Isthmus of Panama; the etcher-illustrator Joseph Pennell preceded him, arriving in January of 1912 to document the proceedings. In fact, Lie was well aware of Pennell's presence in Panama and initially felt that "the field was pretty well covered"; however, on thinking about it further, he realized that "that sort of thing could not be told in black and white only" and decided that it would be well worth his while to go ahead and tackle the enterprise in color.[32]

Lie responded to the magnitude and epic scale of the Panama project: working "in the terrific heat with a sun bonnet,"[33] he created oil studies and drawings and took extensive notes that formed the basis for a series of lively canvases that captured the energy, spirit, and drama of the construction process and serve as valuable historical documents, alluding to the themes of technological progress and man's conquering of the untamed wilderness.[34] In December of that year he exhibited his Panama cycle at M. Knoedler and Company in New York, where attendance on one day totaled 2,120 visitors and purchases were made by both the Metropolitan Museum of Art (Fig. 4) and the Detroit Museum of Art;[35] Lie called the event a "turning point" in his career.[36]

Critical response to the Panama series was exceptionally positive, with commentators such as Royal Cortissoz extolling Lie's simple designs and skillful handling of light and air,[37] and others, among them Arthur Hoeber, praising his ability to capture the "real dignity of labor" and noting that "realistic as is Mr. Lie, he nevertheless manages to invest this practical undertaking with something of poetry."[38] In 1914 Lie's Panama paintings made the rounds of museums in Buffalo, Chicago, and Rochester, and a smaller selection were shown in a separate gallery at that year's annual at the Pennsylvania Academy of the Fine Arts. Lie followed this up a few years later with a cycle of imaginative oils depicting the Bingham

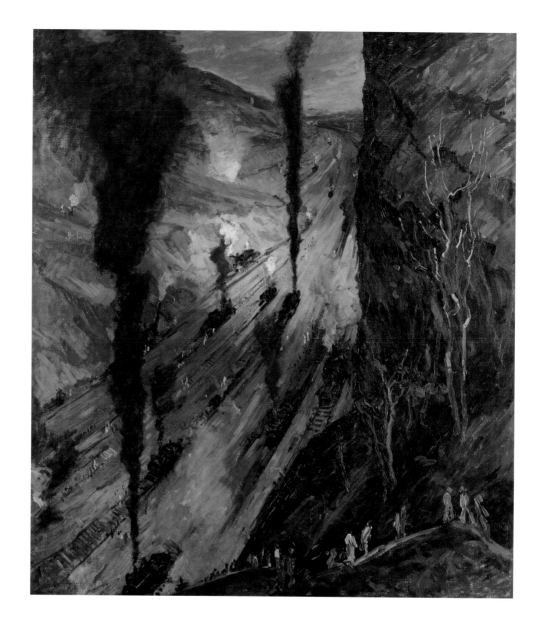

Fig. 4. Jonas Lie, *The Conquerers (Culebra Cut, Panama Canal)*, 1913, oil on canvas, 59¾ × 49⅞ in., The Metropolitan Museum of Art, New York, George A. Hearn Fund, 1914. Photograph © 1989 The Metropolitan Museum of Art

Copper Mines outside of Salt Lake City, Utah, a further testament to his involvement with motifs related to modern-day labor and man's domination of the natural world. However, it was not to last: after the first world war, as his imagery became increasingly personal—shaped and informed by his Nordic background—Lie shifted his attention away from the "deeds of man" and turned to the serene, light-resplendent coastal landscapes and mountain and forest scenes for which he is best known today.[39]

"THEMES WHICH ARE DEAR TO ME": THE SEA, THE MOUNTAINS, AND THE SNOW

He was an American through and through but it must have been partly an
inheritance from his native Norway that enabled him to fill his pictures with
lucent air. He painted them in various parts of the world, in Brittany but far
more in New England and in the Adirondacks. Wherever he painted, he gave them
the tang of nature studied at close quarters, the atmospheric quality which is half
the battle. He had color, too, good color, and American art was made the richer
by his luminous, vivid impressions. A favorite motive of his was a stretch
of water dotted by the white sails of boats and seen through a frame supplied
by gleaming birch trees. He made it beautiful and did so ... not only through
the charm inherent in his vision but through a fine technical authority.
—Royal Cortissoz (1940)[40]

He has always loved snow, feeling, as Scandinavians do, that snow is the year's
coat of ermine, the white mantle that protects ... he sees more than the pictorial
side of snow, he sees its whiteness, its stillness, its rich lusciousness.
—Edgar Cahill[41]

Art is autobiographical ... you cannot put more into
your art than you yourself contain.
—Jonas Lie (1927)[42]

To paint [nature] as the tourist sees it requires the art of panorama;
to paint it as it feels, is the function of the artist.
—Jonas Lie (1931)[43]

WHILE URBAN and industrial scenes were key aspects of Lie's iconography, he was, and continues to be, known primarily for his portrayals of mountains and forests and even more so for his depictions of boats and the sea—subjects that dominated his artistic output of the 1920s and 1930s. His attraction to such motifs is not surprising, for Lie grew up in Norway's capital, Christiania (now

Oslo), a harbor city located on a fjord that afforded him easy proximity to boats and ships of all types as well as access to nearby forests, lakes, and snow-capped mountains. Thus, like most Norwegians, he developed an enduring attachment to the natural wonders of his homeland. It was in Norway, too, where dark winters were followed by the spectral luminosity of summer, that Lie first became aware of the unique and mysterious quality of northern light—an experience that would likewise inform his work as an artist.

Later in his career, Lie credited his parents for exposing him to "such wonderful surroundings."[44] With respect to his maritime interests, in particular, these would have been reinforced by the fact that he was the nephew of the penman and poet, Jonas Lauritz Edemil Lie, who wrote novels and stories about sailors and the sea that his namesake would surely have read.[45] Lie acknowledged the role his Norwegian roots played in his choice of imagery in a revealing letter to his dealer Robert Macbeth, written from the Lofoten Islands in northern Norway in 1925, in which he stated:

> I am sitting in the open window of a fisherman's hut up under the Arctic Circle . . . [where] I see the harbor dotted with numerous small and large islands and crowded with red-sailed fishing craft, and close upon them rise sheer mountain walls from the green sea.
>
> It is a strange sensation to return . . . to the land where I received my first impressions and the strongest. It seems that before the age of ten or twelve, through our environment, our likes and dislikes are established. All these years . . . I [have] used themes which undoubtedly had their origin in my early contacts—such as the sea, the mountains, and the snow, and here I also find myself surrounded by birch and pine.
>
> While painting on the Massachusetts or Maine coast or up in Nova Scotia, I have subconsciously been drawn toward these themes which are dear to me . . . So it comes down to the fact that an art expression is in a sense an autobiography and remains the mirrored reflection of the individual.[46]

Indeed, Lie found his favorite motifs in coastal New England and the Canadian Maritimes and, to a lesser extent, in littoral locales such as Brittany (Fig. 5), Cornwall, and of course, Norway. *Boat at the End of the Jetty* (Cat. 9), which fea-

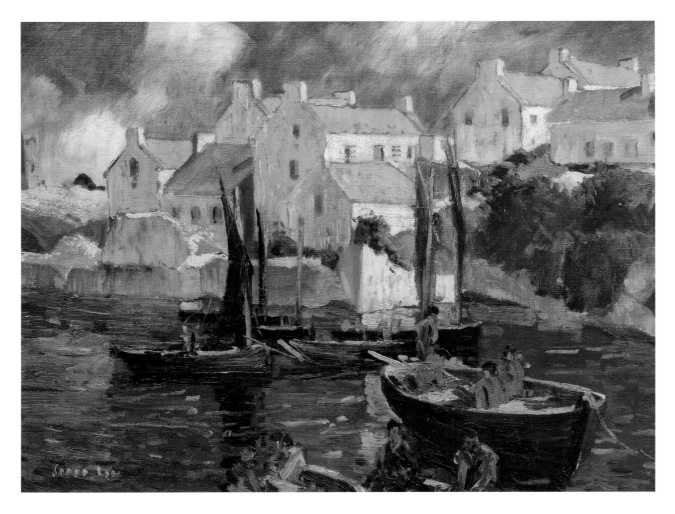

Fig. 5. Jonas Lie, *Brittany Fisher Boats*, ca. 1930, oil on canvas, 15 × 23½ in., photograph courtesy Spanierman Gallery, LLC, New York.

tures a Friendship sloop docked alongside a weather-beaten pier and an old fish shack, is an early example of his forays into marine painting.[47] The exact location of this intimate vignette is not known, but the architecture is typical of that found in the harbors of Massachusetts's Cape Ann peninsula, such as Gloucester, where, during the late 1910s, Lie exhibited in a number of the annual exhibitions held at the Gallery-on-the-Moors.[48]

Lie's connection with nearby Rockport, a well-known artists' colony and fishing port located to the northeast of Gloucester, was considerably stronger and more enduring. The artist began making visits there during the mid-1910s, painting harbor views and the occasional street scene until moving to the Adirondack Mountains of upstate New York in 1923. He returned to Rockport again during the early 1930s, where, as a senior member of the art community, he was much

admired by his younger peers.[49] Rockport provided the inspiration for some of Lie's finest canvases, including *Wharf in Winter* (Cat. 14), in which he presents us with a panoramic view of the inner harbor during a late winter thaw.[50] The focal point of the composition is the weather-beaten red fishing hut on the far right known as Motif No. 1, the town's most celebrated landmark.[51] Often referred to as "the most painted single building in America," this simple shack was built on a granite jetty on Bradley's Wharf during the mid-nineteenth century and was used to store fish, such as mackerel, hoisted in buckets from vessels anchored below.[52] In the painting, Lie's deft brushwork defines forms in a naturalistic manner and eliminates burdensome detail, while his varied palette conveys the dazzling light and frosty air of a winter's day and evokes the look and spirit of Rockport, described by Alice Lawton of the *Boston Post* as a town "rich in color at every season."[53] The large ice floes drifting in the water in the foreground reveal the artist's fondness for flat, decorative patterning—a legacy derived from his former activity as a fabric designer and his interest in Norwegian peasant arts and crafts and old Norse tapestries, which he used to adorn both his house and studio (Fig. 6).[54]

These qualities are apparent, too, in Lie's representations of Norwegian harbors, among them *In a Northern Sea* (Cat. 17), a portrayal of herring boats moored in a quiet inlet flanked by steep cliffs. The division of the composition into distinctive areas of land, water, and sky, the array of sails boldly silhouetted against the rock face and sky, and the undulating contours of the cloud and mountain all contribute to what is a powerful and complex design. The same concern for pattern and repeated forms is evident in *Into the Sunset* (Cat. 33), in which Lie conceives the flotillas of boats as highly stylized, two-dimensional forms that, along with his reductive composition, imbue the image with a stark, near-abstract quality. Dramatic color contrasts are a special keynote of this piece, the dark earth tones and accents of black sharply balanced and offset by pale greens, hints of yellow, and the wonderfully sumptuous orange of the sky.

Lie's liberal use of color is demonstrated to perfection in *The Fleet* (Cat. 26), which features the "red-sailed fishing craft," "sheer mountain walls," and "green sea" he described in his letter to Macbeth. This painting well exemplifies Lie's penchant for depicting clusters of vessels, in this case cod boats huddled around the shore of a small fishing hamlet lying at the base of some rugged, perpendicular cliffs that were no doubt inspired by the jagged mountains of the Lofoten Islands.

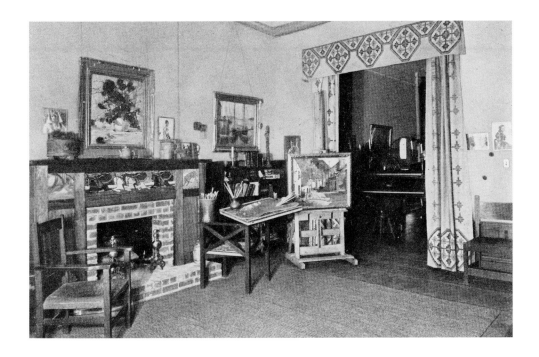

The Fleet is once again a reminder that although Lie has often been branded a conservative who shunned progressive forms of art, his mature aesthetic was informed to varying degrees by the tenets of Post-Impressionism, with its emphasis on simplified shapes, controlled designs, and bold hues applied in an arbitrary manner for emotional purposes and to capture light—in this case that shimmering glow of the midnight sun. As well as drawing on feeling and intuition in choosing his palette, Lie was also guided by his extensive experiments with chromatic effects: both the dealer Frederic Newlin Price and the writer E. May Tennant informed their readers that during the early 1920s, he experimented with color charts to measure complementary contrasts between different hues and to demonstrate his point that "There is no such thing as the isolation of one color. Light and every color change according to the near position of another color. Grey against yellow turns purple, as even a red brick chimney against a yellow sky will assume a purple hue."[55]

Later in his career, Lie's colors grew richer and more intense, while his compositions became even stronger and more forceful. As was pointed out by many reviewers, he continued to explore aspects of light, veering away from the vibrant sunshine seen in earlier works such as *American Factory Town, Winter* (Cat. 8) in favor of a more evocative luminosity—what one writer described as "the half-

broken, glimmering light characteristic of the seaboard and harbors when the fog has lifted and a concealed sun is breaking through."[56]

Lie's penchant for a radiant, all-encompassing luminosity is apparent in a number of stunning oils in the present exhibition that show sweeping vistas of fishing boats and water glimpsed from a shoreline framed by slender birch trees, among them *A Rockport Morning, Maine* (Cat. 23) and *Monhegan Island, Maine* (Cat. 25). The similarities in motif, the artful disposition of close and distant elements, and the use of horizontal formats exemplify Lie's practice of exploring versions of a specific theme and his tendency to arrange his designs and select his palette in accordance with the tranquil ambiance he wished to convey; Lie later recalled that his "keen" sense of compositional design harked back to "the practice I had gotten from making variations on a scheme," presumably in reference to his work as a fabric designer.[57]

These suggestive oils also reveal his habit of selecting his palette according to the tranquil, benign mood he wished to express in his seascapes, which stand as a reflection of his delight in the maritime environment; as he told an interviewer from the *New York Times*, "there is no real art in simply reproducing line and form and color, without interpreting it by real emotions and sensations."[58] To be sure, for Lie, the painting process was highly subjective—not unlike creating a musical composition; as he explained it:

> I do not sit down to make a copy of nature. Rather I take the material nature provides and fashion from it a picture of my own conceiving. I strive for harmonies of form and color, remembering always the handicap under which a painter proceeds as compared with the freedom of the composer who puts down his thoughts and impressions in symphonic form. But in a series of pictures the artist may contrive as many movements as he pleases.[59]

Lie adheres to the same approach in one of his most dazzling canvases, *Amber Light* (Cat. 32), a painting that also bears historical resonance in that it was presented by the artist to his friend President Franklin Delano Roosevelt in 1933. Lie's exact relationship to Roosevelt remains something of a mystery, although the artist was known to have moved in prominent social circles of his day and could surely have established a friendship with the eminent politician through this

means, or through some of his family members, who were in the Norwegian diplomatic service. Both men shared a love of boats and the sea that was established during their respective boyhoods, with Roosevelt learning to sail during childhood summers on Campobello Island in New Brunswick, Canada. In fact, *Amber Light* features a view of Passamaquoddy Bay off Campobello Island, looking toward the east at sunrise. In this instance, the image is pervaded by a dramatic luminosity that seemingly explodes in the sky, casting a glow of light on the bevy of fishing boats, skiffs, and dories in the calm waters of the bay. As reported in *Art Digest*,[60] the large white vessel in the middleground is the Amberjack II, the two-masted schooner that Roosevelt sailed from Marion, Massachusetts, to Campobello in mid-June of 1933 en route to Eastport, Maine, where festivities, fireworks, and a host of dignitaries awaited him.[61]

As in the previously mentioned seascapes, Lie conceived the scene from his imagination, the writer for *Art Digest* reporting that while visiting the White House in the spring of 1933 he had "made a study of the prevailing light effects of the probable spot where the picture would be hung. With this in mind he painted the canvas looking straight toward the rising sun, showing the early morning light reflected in the grayish water on a windy day."[62] Lie's expertise as a colorist is very much in evidence, especially in the luscious blue-greens of the water and in the sky, where gleaming yellows and touches of gold merge and mingle with areas of gray and turquoise—a testament to his dictum that color is the "chief medium through which we attain pictorial expression" and that "color must be interpretative, not imitative."[63] Certainly, the artist's exuberant palette and his astute manipulation of form and light capture the commemorative nature of Roosevelt's journey and his arrival, after a lengthy absence, at Campbello on June 29th; according to one account of the event,

[the day] dawned with a thick fog blotting out views of the *Indianapolis* and the other naval craft that had preceded Franklin to Eastport. The local herring fleet . . . was "properly dressed for the occasion," and lay at anchor off Welshpool. Then, as if by magic, the fog lifted, and the sun shone through a cloudless sky. 'The schooner [*Amberjack II*] sailed quite majestically through the Narrows and tacked across Passamaquoddy Bay, and Franklin landed at Welshpool for the first time in a dozen years.[64]

An unqualified success, *Amber Light* was described as "alluring" by the critic James Huneker, while Roosevelt himself told the artist he was "thrilled" with it, "Dozens of people agree with me that it is the nicest thing you've done."[65]

Mood-oriented coastal scenes from the early 1930s such as this were among those later canvases that caught the eye of New York critics such as Margaret Breuning, who, on the occasion of an exhibition of Lie's work at Macbeth's in 1934, proclaimed that these later marines represented an advancement in Lie's development; in her opinion, they revealed "far greater amplitude of powers, more penetration of the inner significance of the idea presented . . . [and] more harmony of objective treatment and subjective mood" than in his previous efforts.[66] Royal Cortissoz of the *Herald-Tribune* was equally enthusiastic, stating that

> There was always good color in his work, but now he seems to have it under better control . . . and especially to have made a securer equilibrium between his color and his light Everywhere in these studies of the New England coast Lie has found light and air, the movement of life, and he has not forgotten the requirements of design. He has grown in artistic stature.[67]

While littoral subjects occupied much of Lie's creative energies throughout his career, he was equally drawn to mountain and forest themes, finding inspiration in the woodlands of Maine, where he encountered the unspoiled scenery and clear, transparent air reminiscent of Norway. He also experienced similar atmospheric conditions and motifs in the Adirondack Mountains of northeastern New York, a wilderness region that had been attracting painters since the late 1830s, when artists such as Thomas Cole and Asher B. Durand first discovered the unspoiled beauty of its primordial forests and magnificent sunsets.[68] These artists were followed by successive generations of painters that included Arthur Fitzwilliam Tait and Winslow Homer, who concentrated their attention on scenes related to the region's hunting, fishing, and trapping—a subject Lie touched on himself (Cat. 22), albeit rarely.

Lie began visiting the Adirondacks as early as 1921, and during 1923–24 he resided year-round in Saranac Lake while his second wife was treated for tuberculosis at the Trudeau Sanatarium. It was probably during this period that he painted *September* (Cat. 18), an oil that demonstrates another preferred compositional

scheme—that of a waterway flanked by lithe birch trees silhouetted against distant mountains. Lie painted this type of view throughout the seasons, but he was especially fond of depicting it under a blanket of snow—an inclination that harks back to his Nordic heritage (Fig. 7). At the same time, Lie admitted to having been influenced by the work of the foremost Norwegian impressionist Frits Thaulow,[69] whose renderings of rushing waterways, painted in a style that conjoined naturalism with the coloristic innovations of Impressionism, informed his own river and forest landscapes.[70]

Lie's interpretation of the stream-in-a-landscape theme could be bold and intensely colored, as in works such as *First Thaw* (Cat. 15) and *Northern Hills* (Cat. 13), works that in the vigor of their technique call to mind the equally broadly-rendered oils of the Pennsylvania landscapist Edward Redfield, yet he could also more

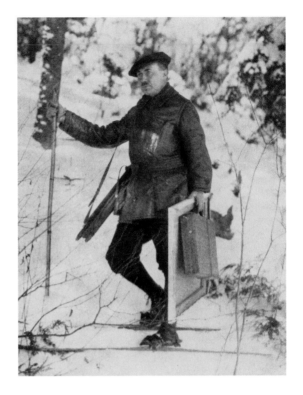

Fig. 7. This photograph of Lie outdoors with his painting materials appeared on the cover of the catalogue accompanying his one-man exhibition at New York's Ainslie Galleries in April of 1923. Courtesy Ellen von der Lippe.

fleeting and subtle in his take on the subject, as in the magnificent *Winter Landscape* (Cat. 34), one of his most thorough excursions into Impressionist light, color, and facture. Lie's predilection for combining snow-covered terrain, frigid water, sun-dappled birch trees, and a background of dense woodlands is also apparent in *Winter Blue* (Cat. 5), although in this case he eschews the wide panorama for an abruptly cropped close-up that could have been inspired by scenery in the Adirondacks or New England. Lie's chromaticism, dominated by the cool blues, which are in turn echoed in the work's title, are very much in keeping with his subject and with outdoor conditions of strong sunlight, contrasting shadows, and frigid air—a visual echo of Lie's statement that "All the keys and chords and harmonies of my work come from the North."[71]

Lie's engagement with Adirondack scenery continued beyond his 1923–24 residency in the area, for in 1928 he was commissioned by Mr. and Mrs. Francis P. Garvan to paint a series of oils depicting their summer residence Kamp Kill Kare on Lake Kora.[72] Consistent with his affection for winter, Lie chose to carry out the project in February of 1930, spending a month at the camp, where, taking advantage of the unusually mild conditions that year, he painted ten oils, ranging from

lake scenes and painterly views of groves of silver birches (Cat. 28) to representations of camp buildings, such as the boathouse and stables. Lie also applied his brush to the camp's Norman-style stone chapel (Cat. 29), showing it nestled comfortably amid a snow-bound setting, protected by a canopy of tall evergreens that were part and parcel of the Adirondack environment, their broad branches creating the patterning that became a vital component of Lie's mature canvases.[73]

Jonas Lie continued to paint light-filled landscapes and marines (Cat. 35) well into the 1930s, a period when he made summer painting trips to Holland and Cornwall (1937) and to Maine and Québec's Gaspé peninsula (1939). Apropos his belief that an artist "should serve, as well as paint,"[74] he combined his artistic activity with his role as an administrator, holding a position on the Art Students League's Board of Control during 1931–33, at which time he became embroiled in a heated debate with the painter and league president John Sloan over the proposed hiring of the German Modernist, George Grosz, a controversy that led to Sloan's eventual resignation.[75] A buoyant and energetic individual who held strong opinions, Lie was appointed president of the venerable National Academy of Design in 1934, where, during his five-year tenure, he oversaw a number of reforms, which included reorganizing the jury of selection so that younger members could be elected to the academy and appointing a group of liberal-minded artists to oversee the institution's free art school.

Appropriately, the numerous tributes that followed in the wake of Lie's death in January of 1940 outlined his various executive posts and professional affiliations as well as his numerous awards and honors, but, for the most part, they focused on his reputation as one of the most celebrated painters of his day—an artist who portrayed his environment in a vital, lusty aesthetic that fused observed reality with subjective insight and experience. In the words of Henry Rittenberg, a fellow national academician,

He was a firm, forceful, sturdy painter. A poet—so saturated with the beauty and mysterious moods of nature, which he so masterfully depicted, that in my opinion Jonas Lie left behind him a record—his own, that will live as important Americana—and Time alone will prove that.[76]

1. Rose V. S. Berry, "Jonas Lie" The Man and His Art," *American Magazine of Art* 16 (February 1925): 66.

2. Jonas Lie, interview by DeWitt McClellan Lockman, 9 June 1927, typescript, 32, DeWitt McClellan Lockman Papers, Archives of American Art, Smithsonian Institution, Washington, D.C., reel 503, fr. 754.

3. Jonas Lie quoted in "Jonas Lie—Painter," *Index of Twentieth Century Artists* 1 (August 1934): 225.

4. In conjunction with my research on Lie's life and work, I would like to acknowledge the following individuals: Ellen von der Lippe; Robert G. Bardin; and Stephanie Cassidy, archivist, Art Students League of New York. I would also like to thank Kristen Wenger, Spanierman Gallery, for her diligent work relative to document and photograph retrieval and bibliographic verification. Lie material in the Spanierman Gallery Library and artist file was supplemented by additional resource data gathered by Ruth Pasquine and generously shared with me by William H. Gerdts.

5. [James Huneker], "Around the Galleries," *Sun* (New York), 7 January 1907, p. 6.

6. "Jonas Lie of Norway and America: A Painter Who has Found the Secret of Suggesting on Canvas Nature's Manifold Moods," *Craftsman* 13 (November 1907): 135–39.

7. "A Norwegian Artist—Interpreter of America," *Current Literature* 52 (February 1912): 222.

8. J. Nilsen Laurvik, quoted in "A Norwegian Artist—Interpreter of America," 224.

9. Lorinda Munson Bryant, *American Pictures and Their Painters* (New York: John Lane Company, 1917), 216.

10. "Jonas Lie—Painter," 225.

11. Peyton Boswell, "Jonas Lie." *Art Digest* 14 (15 January 1940): 3.

12. See Dewing Woodward, "The Readers Comment: He [*sic*] Knew Jonas Lie," *Art Digest* 14 (15 May 1940): 13. The editor obviously forgot, or did not realize, that Woodward was a woman.

13. I would like to thank Marshall Price, assistant curator, National Academy of Design, for checking the student registers on my behalf.

14. Lie, interview by Lockman, 12, fr. 732.

15. For the Country Sketch Club, see "The Country Sketch Club," *Art Collector* 9 (1 June 1899): 230, and Bailey Millard, "The Painters of the Palisades," *Bookman* 35 (May 1912): 256–65. See also Lolita Flockhart, *A Full Life: The Story of Van Dearing Perrine* (Boston: Christopher Publishing House, 1939).

16. See Millard, 260.

17. Lie, interview by Lockman, 34, fr. 756. For a definitive study of Tonalism, see Ralph Sessions, et al., *The Poetic Vision: American Tonalism*, exh. cat. (New York: Spanierman Gallery, 2005).

18. Christian Brinton, "Jonas Lie: A Study in Temperament," *American-Scandinavian Review* 3 (July–August 1915): 200.

19. Jonas Lie, quoted in "Painter Off Today for Lonely North," *New York Times*, 25 April 1926, sec. 2, p. 22.

20. "Jonas Lie—Painter," 225.

21. For Lie's activity as a decorator, see Jessie Martin Breese, "Jonas Lie—His House and Others," *Country Life in America* 36 (July 1919): 55–57.

22. See Brinton, "Jonas Lie: A Study in Temperament," 207.

23. Lie describes this in his interview with Lockman, 21, fr. 742.

24. Lie, interview by Lockman, 21, fr. 742.

25. Lie, interview by Lockman, 33, fr. 755.

26. For the Armory Show, see Milton W. Brown, *The Story of the Armory Show* (New York: Abbeville Press, 1988). American artists who participated in the exhibition included Philip Leslie Hale, Oscar Bluemner, and William Zorach.

27. "A Patriot in Paint: Jonas Lie," *Arts and Decoration* 12 (December 1919): 91.

28. Edgar Cahill, "Jonas Lie: Poet of Today," *Shadowland* 7 (February 1923): 11.

29. Lie, interview by Lockman, 19, fr. 740.

30. Brinton, "Jonas Lie: An Interpretation," in *Jonas Lie*, exh. cat. (New York: Ainslie Galleries, 1923), unpaginated.

31. Richard Beer, "As They Are: 'Time for Living,' " *Art News* 32 (28 April 1934): 11.

32. As would the California Impressionist Alson Skinner Clark, who arrived in March 1913, shortly after Lie.

33. Lie, interview by Lockman, 24, fr. 746.

34. Lie, interview by Lockman, 25, fr. 747. For artists at the Panama Canal, see Joseph Masheck, "The Panama Canal and Some Other Works of Work," *Artforum* 9 (May 1971): 38–41.

35. Known today as the Detroit Institute of Arts.

36. Lie, interview by Lockman, 25, fr. 747. Detroit purchased *The Culebra Cut*.

37. Royal Cortissoz, "First to Carry Absolute Conviction in reproducing the Great Work," *New York Herald Tribune*, 6 January 1914, quoted in *What the Critics say about Jonas Lie's Paintings of The Panama Canal* [1914?], [2].

38. Arthur Hoeber, *New York Globe*, 30 December 1913, quoted in *What the Critics say about Jonas Lie's Paintings of The Panama Canal*, [2].

39. Cahill, "Jonas Lie: Poet of Today," 11.

40. Royal Cortissoz, "Jonas Lie," in *Commemorative Tributes of the American Academy of Arts and Letters, 1905–1942* (New York: American Academy of Arts and Letters, 1942), 398.

41. Cahill, "Jonas Lie: Poet of Today," 11.

42. Lie, interview by Lockman, 34, fr. 756.

43. Jonas Lie, quoted in "Jonas Lie At Macbeth's," *Brooklyn Daily Eagle*, 18 January 1931.

44. See Breese, "Jonas Lie—His House and Others," 56.

45. See "Jonas Lie Dead," *New York Times*, 6 July 1908, p. 7.

46. Jonas Lie to Robert Macbeth, quoted in *Exhibition of Paintings by Jonas Lie, N.A.*, exh. cat. (New York: William Macbeth Galleries, 1926), unpaginated. See also Jonas Lie, Svolvaer, Lofoten, Norway, to Robert Macbeth, New York, June 1925, Macbeth Gallery Papers, Archives of American Art, reel NMc59, fr. 1023.

47. I would like to thank Robert G. Bardin for identifying the vessel, so-named after the small port town in Maine where it was developed.

48. See James F. O'Gorman, *This Other Gloucester* (Gloucester, Mass.: Ten Pound Island Book Co., 1990), 89, 92.

49. For Lie and Cape Ann, see Kristian Davies, *Artists of Cape Ann: A 150 Year Tradition* (Rockport, Mass.: Twin Lights Publishers, Inc., 2001), 86-87. Davies notes that during the 1930s, Lie maintained a studio on Bearskin Neck. He later resided in the Hannah Jumper House on Mount Pleasant Street.

50. In terms of subject and composition, this work is directly related to *Midwinter* (ca. 1920, Norwegian Embassy, Washington, D.C.).

51. Lie would typically make sketches of the harbor, often working from the window of a nearby warehouse. He would then translate these studies into larger oils in his studio, sometimes altering the composition in accordance with the effect he wished to convey.

52. See Irma Whitney, "Motif No. 1," in Kitty Parsons Recchia, comp., *Artists of the Rockport Art Association*, reprint (Rockport, Mass.: Rockport Art Association, [1989]), 134. The building was dubbed "Motif No. 1" by the painter Lester Hornby, who conducted outdoor painting classes in Rockport.

53. Alice Lawton, "Rockport-An Art World in Miniature," in Recchia, 136.

54. See Breese, "Jonas Lie—His House and Others," for Lie's forays into Viking-inspired interior décor.

55. Jonas Lie quoted in F[rederic] Newlin Price, "Jonas Lie, Painter of Light," *International Studio* 82 (November 1925): 107. See also: E. May Tennant, "Jonas Lie, Citizen-Artist," *Arts and Decoration* 15 (August 1921): 221.

56. "Lie Exhibits His 'Light and Air' Paintings," *Art Digest* 12 (15 April 1938): 16.

57. Lie, interview by Lockman, 13, fr. 733.

58. Jonas Lie, quoted in "Painter Off Today for Lonely North."

59. E. A. J. [Edward Alden Jewell], "Further Comment on Exhibitions: Off to Venice, By Way of Africa, A Picture Journey Conducted by Jonas Lie, Erick Berry, Maclet and Favai," *New York Times*, 1 January 1928, sec. 8, p. 13.

60. "A Painting for the President," *Art Digest* 8 (15 December 1933): 26.

61. See Jonas Klein, *Beloved Island: Franklin and Eleanor and the Legacy of Campobello* (Forest Dale, Vt.: Paul S. Erikson, 2000), 140. I would like to thank Robert G. Bardin for bringing this source to my attention.

62. "A Painting for the President."

63. Jonas Lie quoted in Brinton, "Jonas Lie: A Study in Temperament," 205.

64. Quoted in Klein, 145. This was Roosevelt's first visit to Campobello since contracting polio and the first instance in which an American president vacationed in Canada.

65. F. D. R. [Franklin Delano Roosevelt], Washington, D.C. to Jonas Lie, Esq., New York City, 14 November 1933, photocopy in the Jonas Lie file, Spanierman Gallery, LLC.

66. Margaret Breuning, quoted in "New York Criticism: Jonas Lie Astonishes Critics," *Art Digest* 8 (1 April 1934): 14.

67. Royal Cortissoz quoted in "New York Criticism."

68. For a recent study of art in the Adirondacks, see Patricia C. F. Mandel, *Fair Wilderness: American Paintings in the Collections of the Adirondack Museum*, exh. cat. (Blue Mountain Lake, N.Y.: Adirondack Museum, 1990).

69. Lie, interview by Lockman, 34, fr. 756.

70. Lie told DeWitt Lockman that during his 1909–10 trip to Norway, he visited Lillehammer, where "the Norwegian Fritz Thurlow [sic] has painted so much. There's where he did his rivers, etc." See Lie, interview by Lockman, 21, fr. 742.

71. Jonas Lie quoted in "Painter Off Today for Lonely North."

72. For this commission, see Anthony N. B. Garvan, *Adirondack Winter—1930: Paintings by Jonas Lie*, exh. cat. (Blue Mountain Lake, N.Y.: Adirondack Museum, 1971).

73. The chapel was possibly designed by architect John Russell Pope and erected in 1918. Information courtesy the Adirondack Museum.

74. Rilla Jackman, *American Arts* (Chicago: Rand McNally & Company, 1940), 289.

75. Lie felt that Grosz lacked the technical expertise necessary to the teaching of art; as he explained it, he opposed the "importation of European artists to teach us unless they are well instructed in the fundamentals necessary to the development of American art; and I do not feel that George Grosz, judged by the type of work he has done, would be a fortunate choice for our students." See "Sloan Quits in Row as Art League Head," *New York Times*, 9 April 1932, p. 17.

76. Henry R. Rittenberg, "Tribute to Jonas Lie in My Talk 'The Art Problem of Today' at the Studio Club, February 8th, 1940," typescript, [1940?], photocopy in the Jonas Lie file, Spanierman Gallery, LLC.

1.

Birches, 1903
(New Jersey or New York)
Oil on canvas
22 × 18 inches
Signed and dated lower right: *Jonas Lie. 03.*

2.

Flood, Plainfield, New Jersey, ca. 1905
Oil on canvas
20½ × 26¼ inches

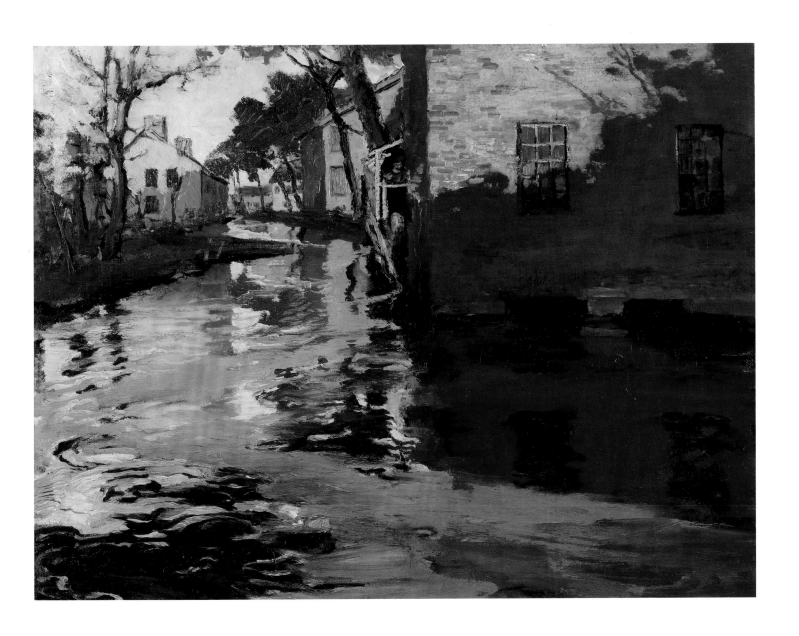

3.

Quiet Town, 1909
(Norway)
Oil on canvas
26 × 35 inches
Signed and dated lower left: *Jonas Lie 1909*

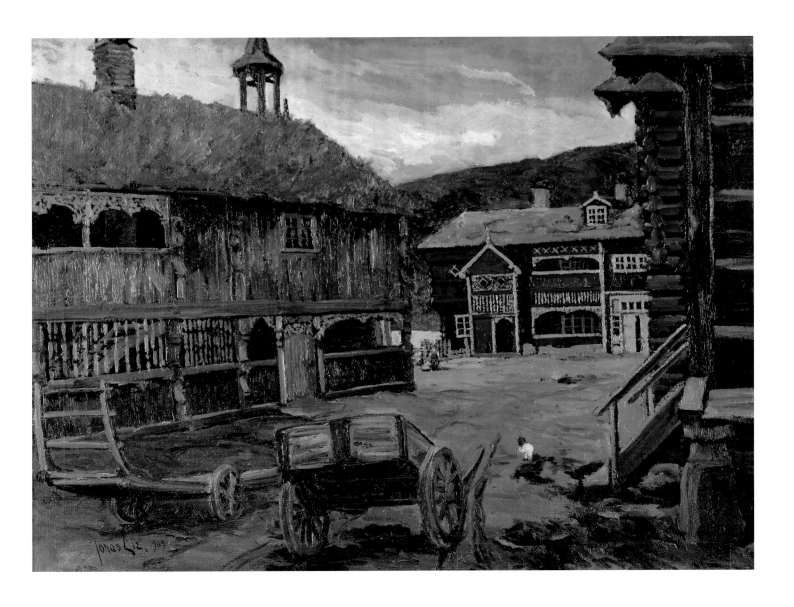

4.

Landscape, ca. 1910
(New York or New England)
Oil on canvas
12 × 9 inches

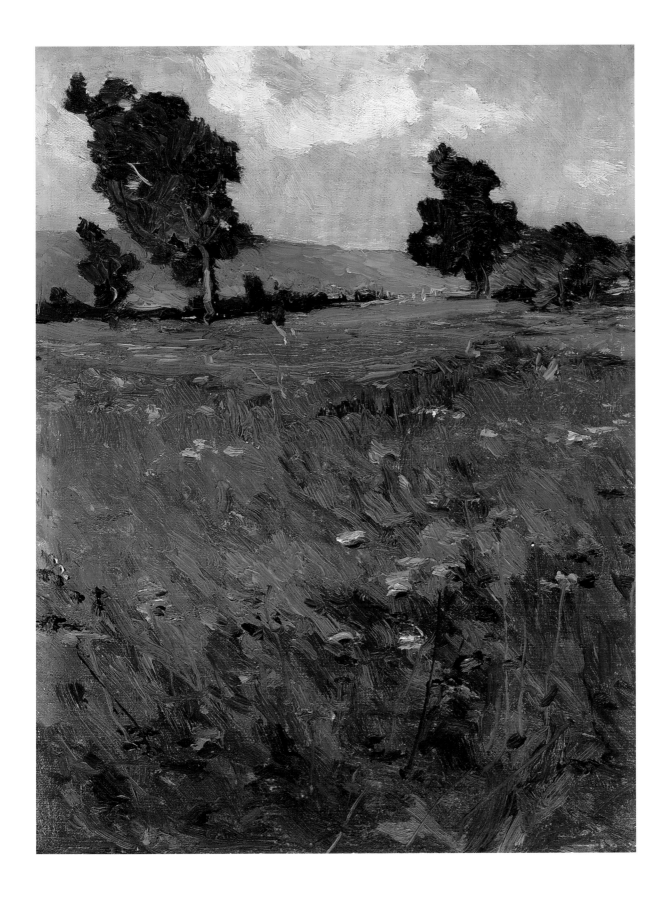

5.

Winter Blue, 1913
(New York or New England)
Oil on canvas
30⅛ × 40⅛ inches
Signed lower right: *Jonas Lie*
Signed and dated on stretcher: *Jonas Lie 1913*

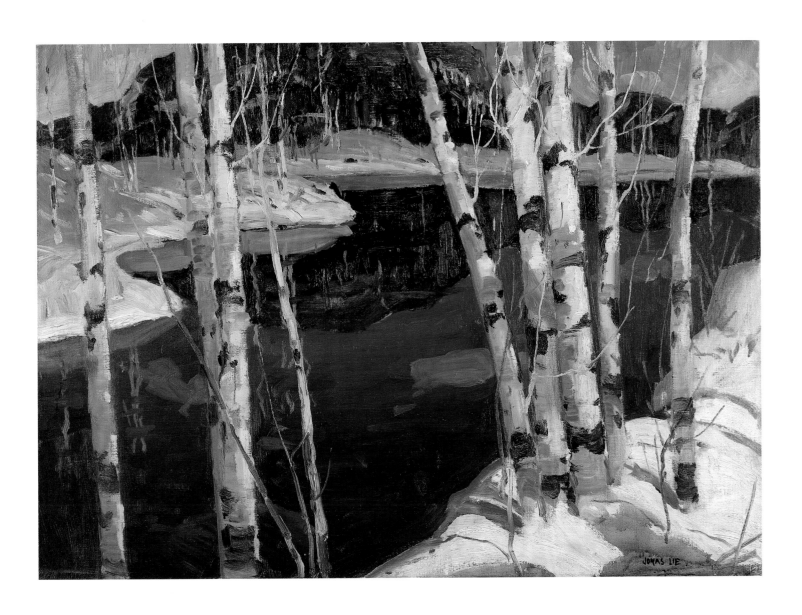

6.

Land's End, ca. 1910–20
(Cape Ann, Massachusetts)
Oil on canvas
30 × 60 inches
Signed lower left: *Jonas Lie*

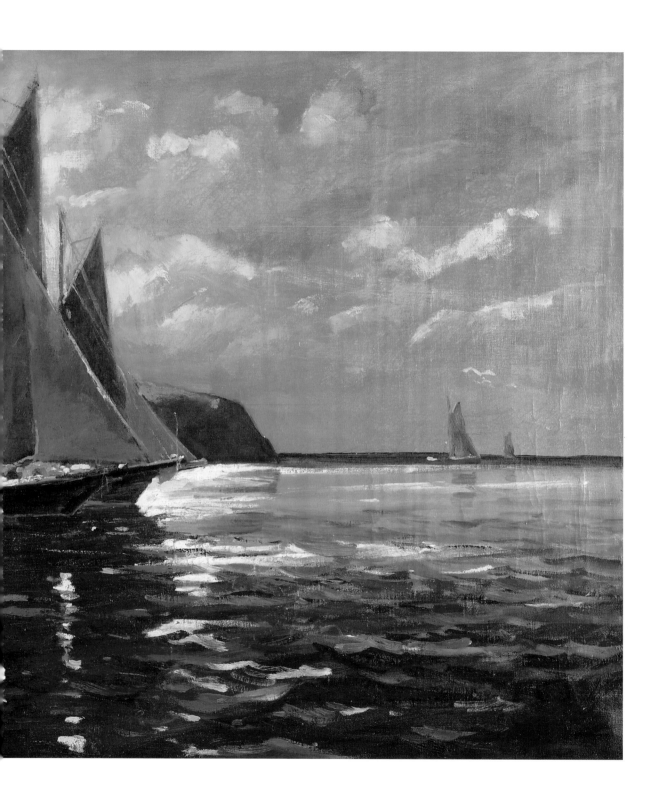

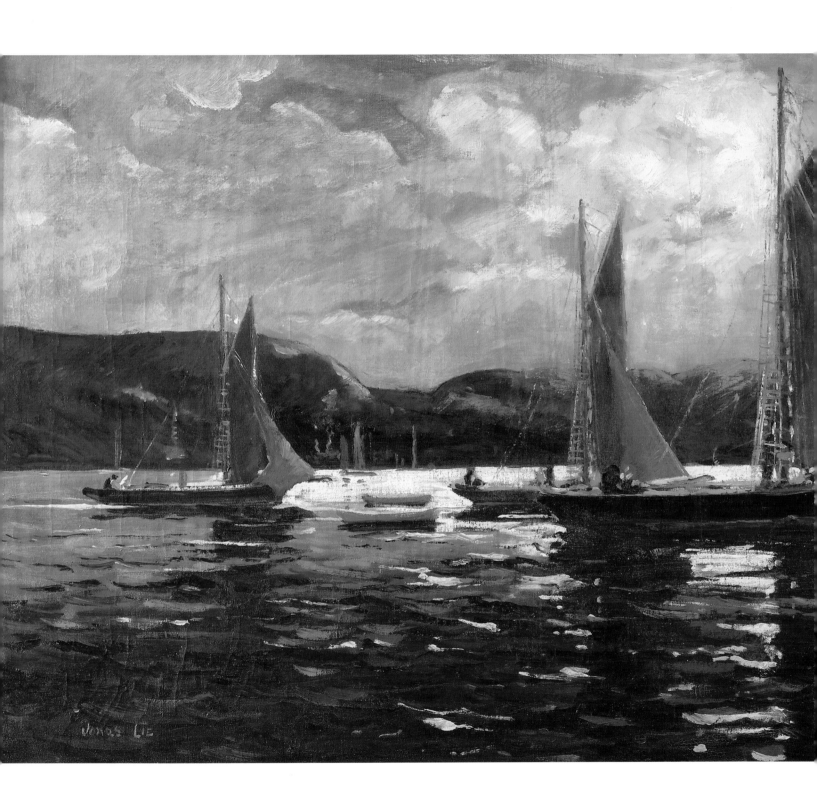

7.

Study for The Conquerors:
Culebra Cut, Panama Canal, 1913
Oil on canvas laid down on board
12¼ × 10 inches
Signed, dated, and inscribed lower right:
Jonas Lie. / Panama, 1913
Collection of Fred Doloresco

8.

American Factory Town, Winter, ca. 1916
Oil on canvas
41 × 35 inches
Signed lower right: *Jonas Lie*

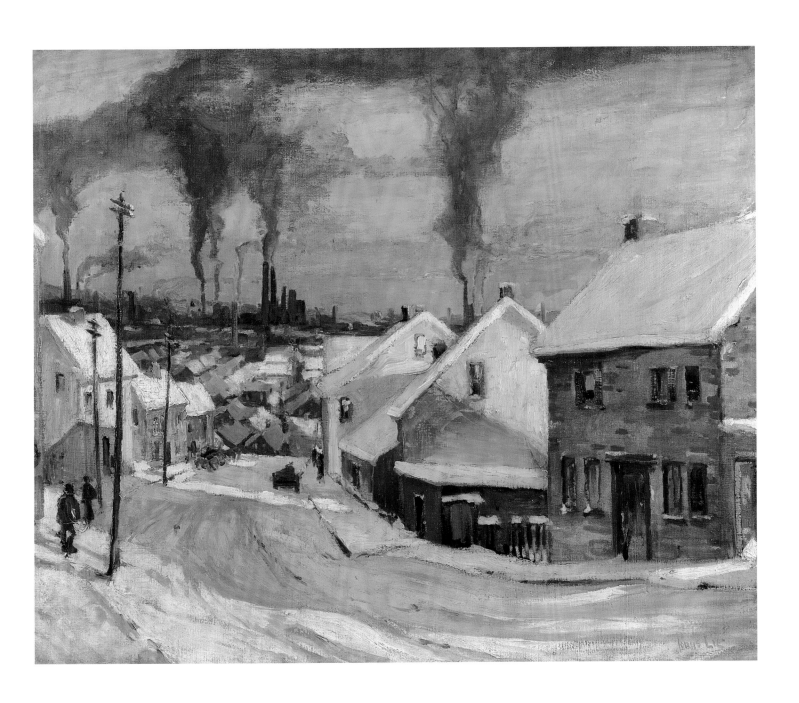

9.

Boat at the End of the Jetty, ca. 1914–20
(New England)
Oil on canvasboard
11⅜ × 9½ inches
Signed lower right: *Jonas Lie*

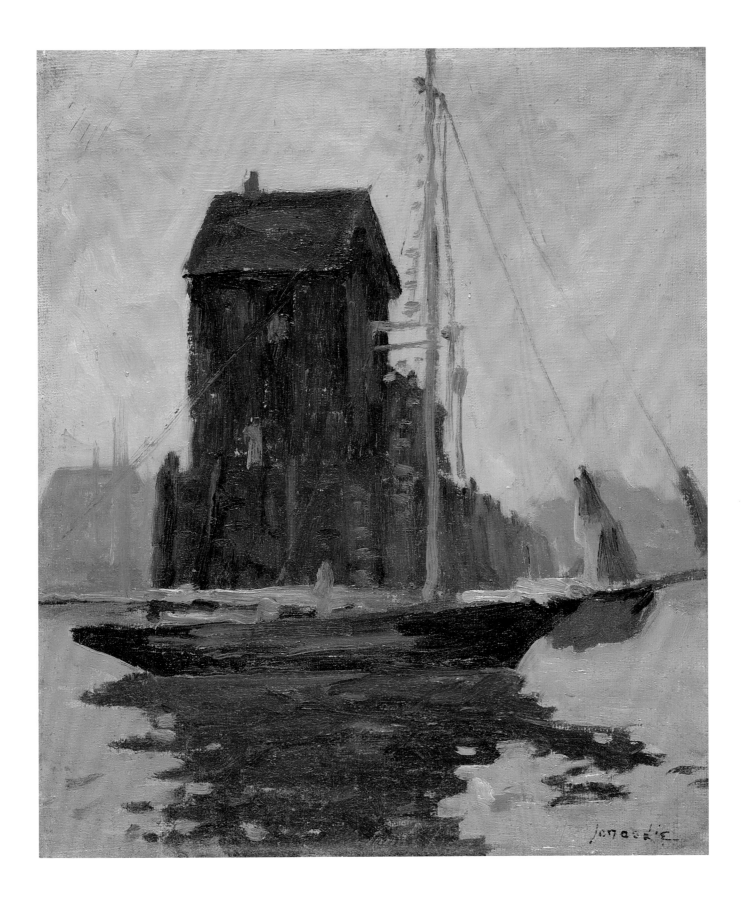

10.

Old Covered Bridge, ca. 1910–20
(New York or New England)
Oil on canvas
25 × 30 inches
Signed lower right: *Jonas Lie*

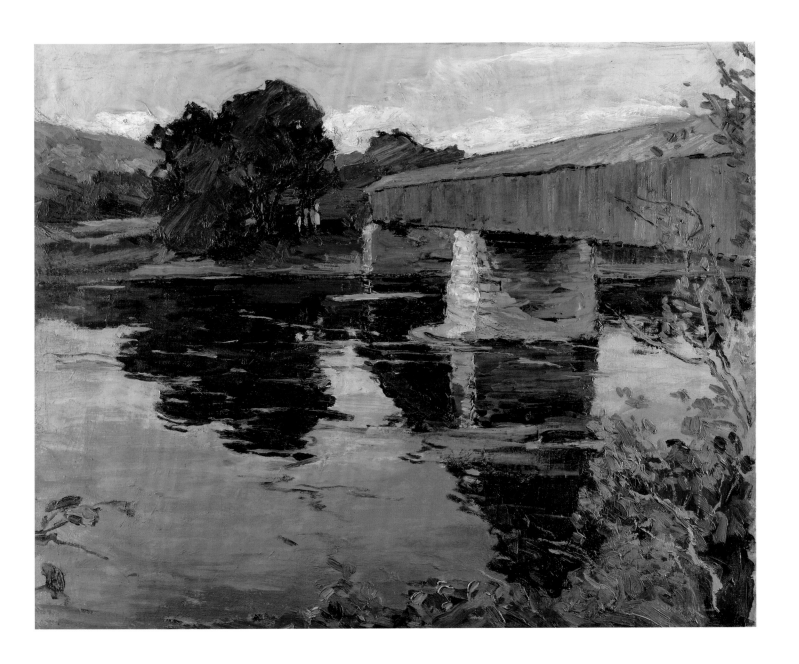

11.

Boating on a Lake, ca. 1920
(probably New England)
Oil on canvas
30 × 60 inches
Signed lower left: *Jonas Lie*

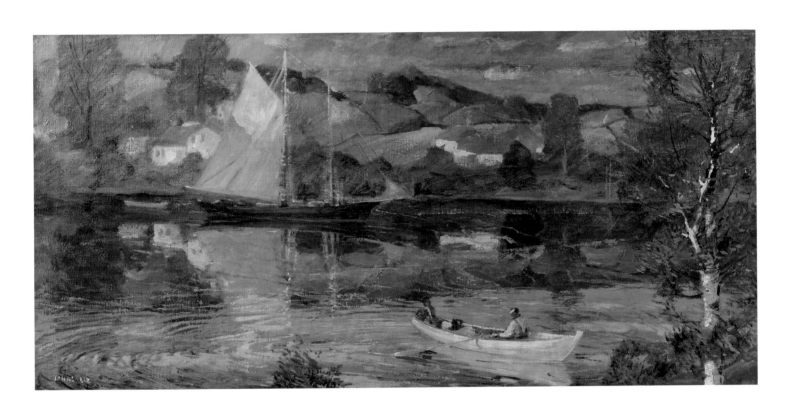

12.

Brooklyn Navy Yard, ca. 1918
Oil on canvas
34¼ × 53¼ inches
Signed lower left: *Jonas Lie*

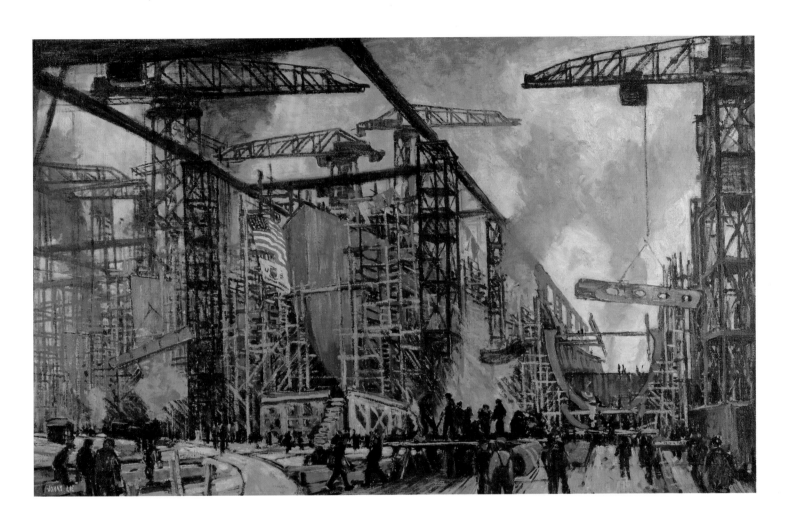

13.

Northern Hills, 1922
(New York)
Oil on canvas
30 × 40 inches
Signed and dated lower right: *Jonas Lie '22*

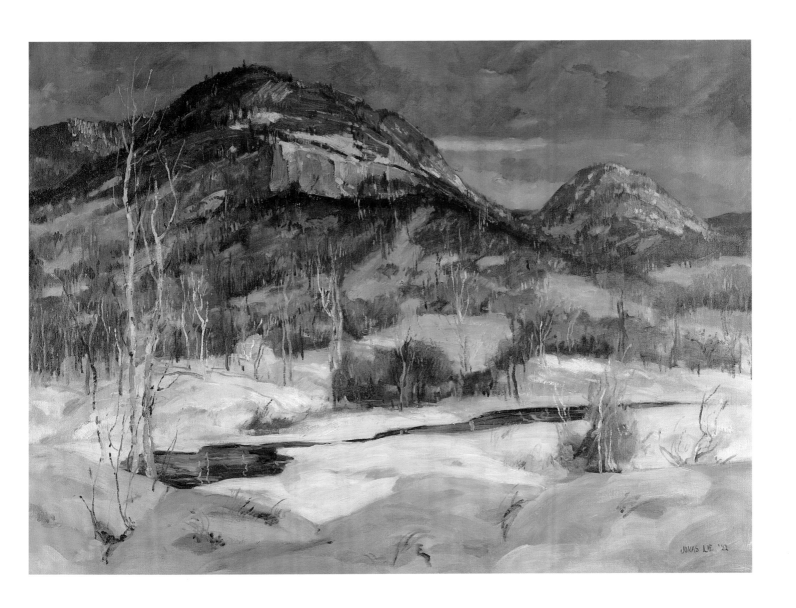

14.

Wharf in Winter, ca. 1920
(Rockport, Massachusetts)
Oil on canvas
29½ × 44½ inches
Signed lower right: *Jonas Lie*

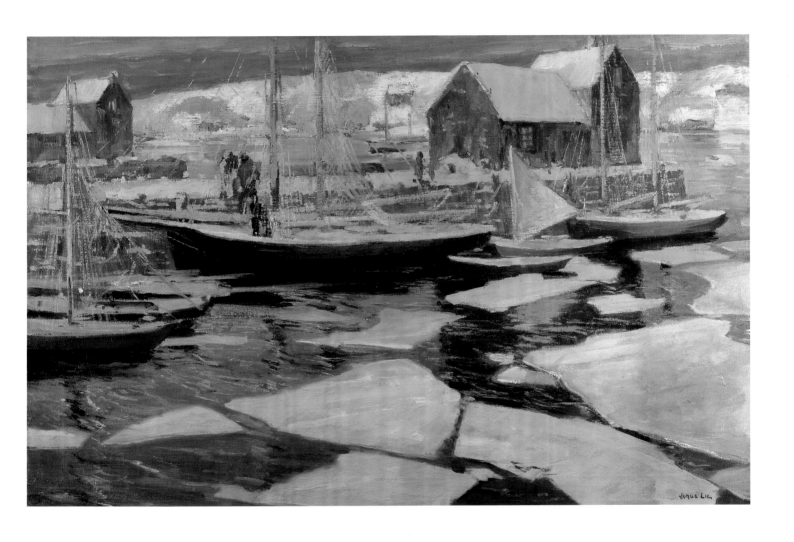

15.

First Thaw, ca. 1921–23
(New York)
Oil on canvas
30 × 50 inches
Signed lower left: *Jonas Lie*

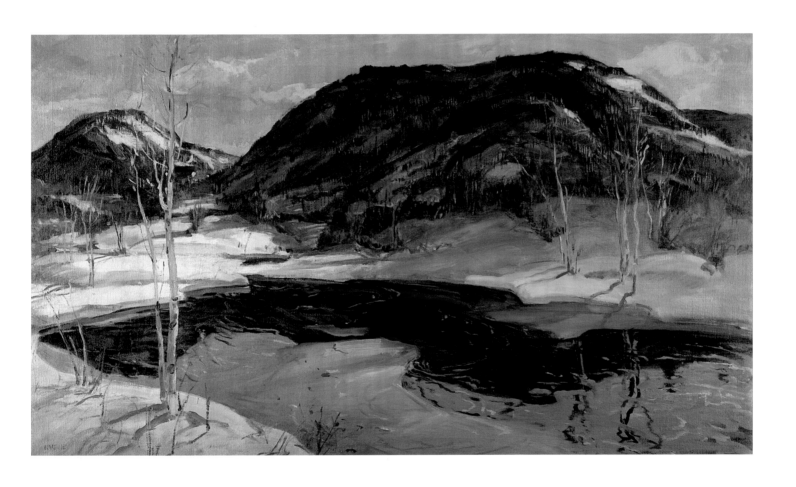

16.

Provincetown Harbor, ca. 1920s
(Massachusetts)
Oil on canvasboard
12 × 16 inches
Signed lower right: *Jonas Lie*

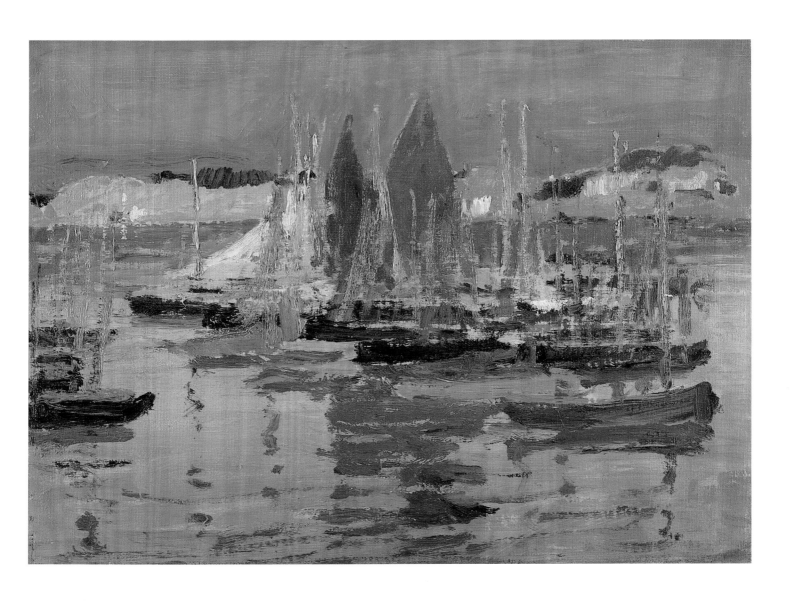

17.

In a Northern Sea, ca. 1920
(Norway)
Oil on canvas
30 × 36 inches
Signed lower right: *Jonas Lie*

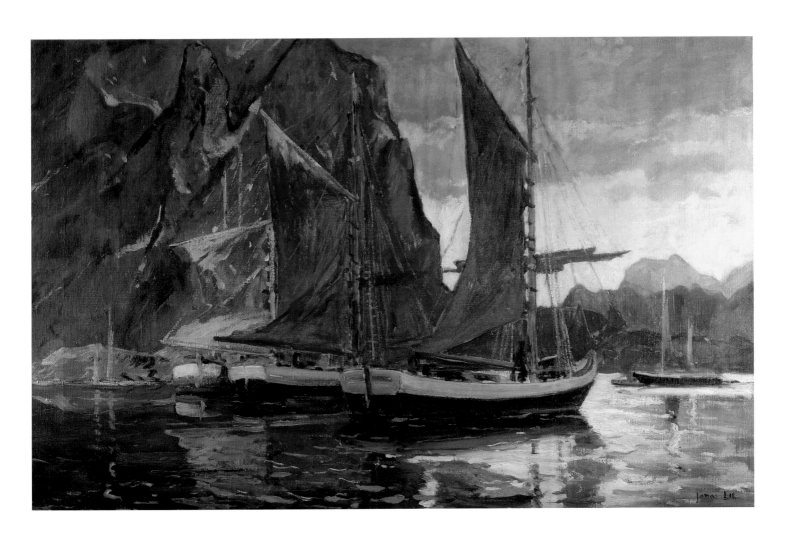

18.

September, ca. 1922
(New York or New England)
Oil on canvas
30½ × 40½ inches
Signed lower left: *Jonas Lie*

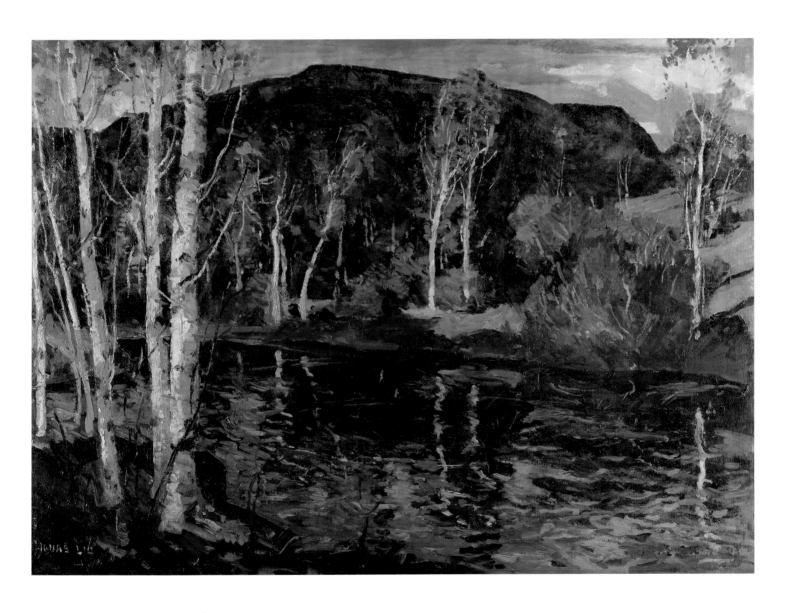

19.

Autumn Sunset, ca. 1920s–30s
Oil on canvas
26 × 30 inches
Signed lower left: *Jonas Lie*

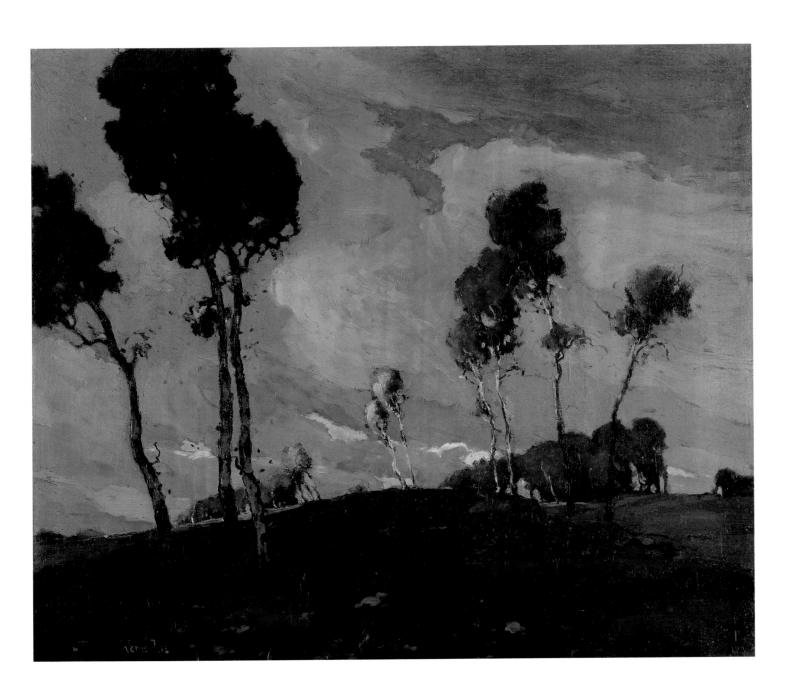

20.

Harbor Sails, ca. 1920s–early 1930s
Oil on board
8½ × 9¾ inches
Signed lower right: *Jonas Lie*

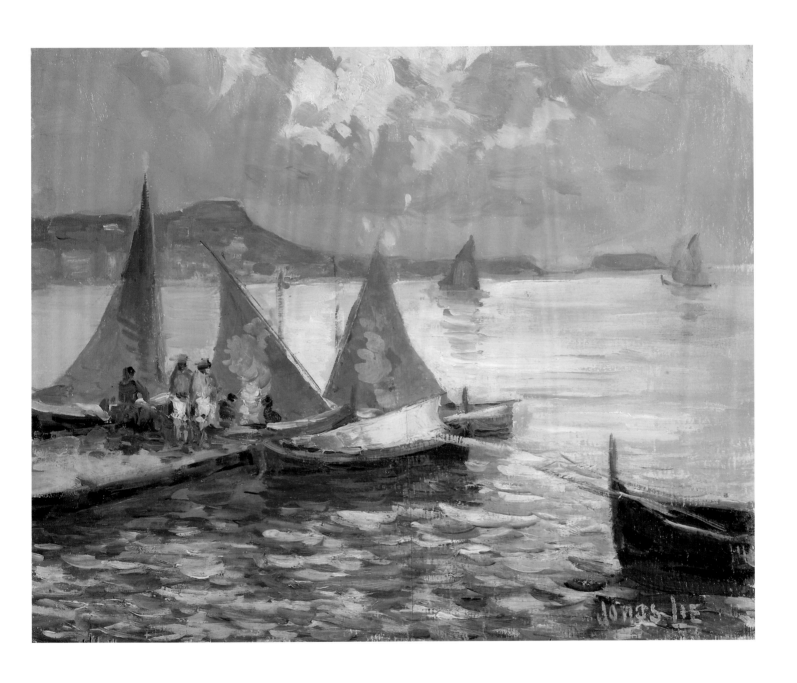

21.

Adirondacks Winter, ca. 1921–23
Oil on canvas
50 × 50 inches
Signed lower right: *Jonas Lie*
Private Collection

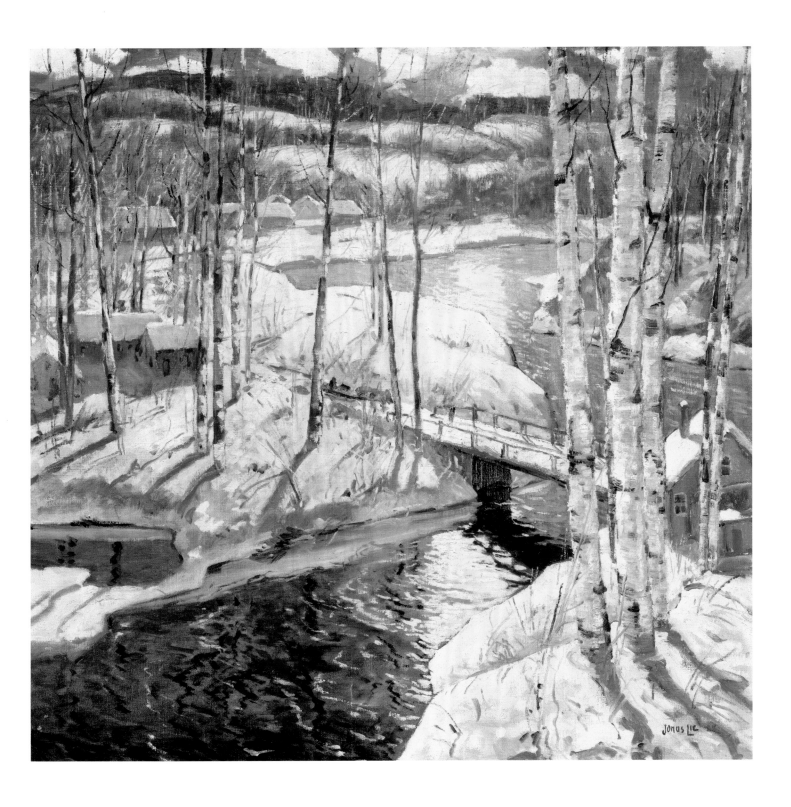

22.

The Hunter, ca. 1923
(New York or New England)
Oil on canvas
23½ × 34 inches
Signed lower left: *Jonas Lie*

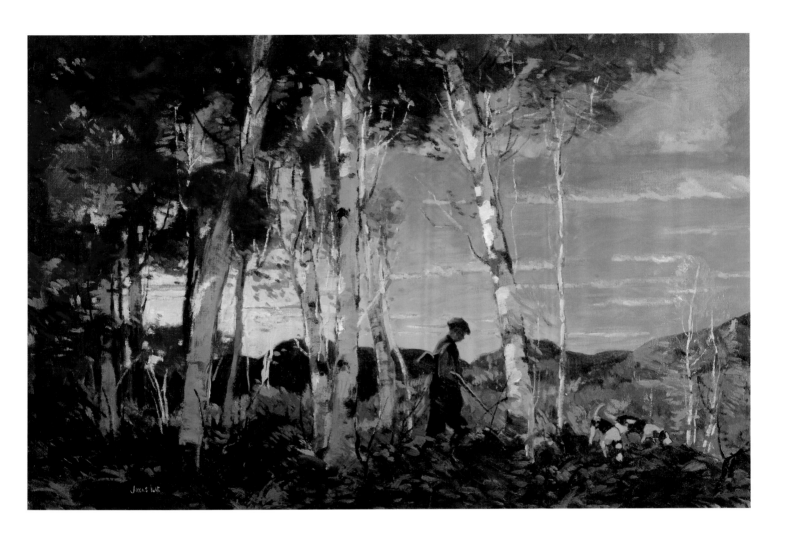

23.

A Rockport Morning, Maine, ca. 1927
Oil on canvas
22 × 40 inches
Signed lower right: *Jonas Lie*

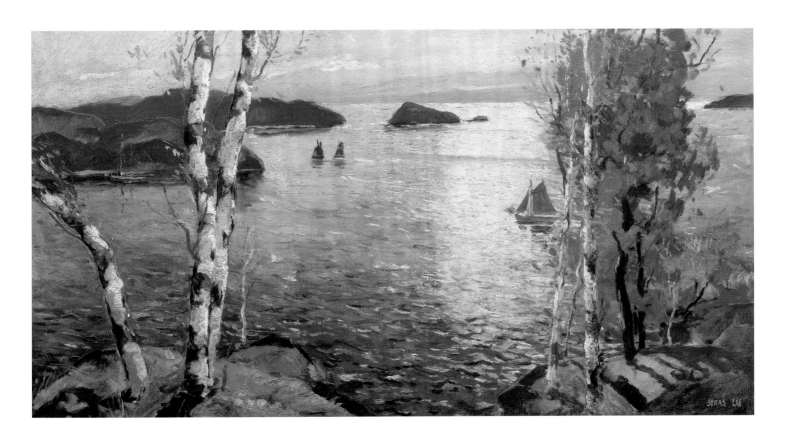

24.

Boats in the Harbor, ca. 1925

Pastel and ink on paper

15 × 11 inches

Signed lower left: *Jonas Lie*

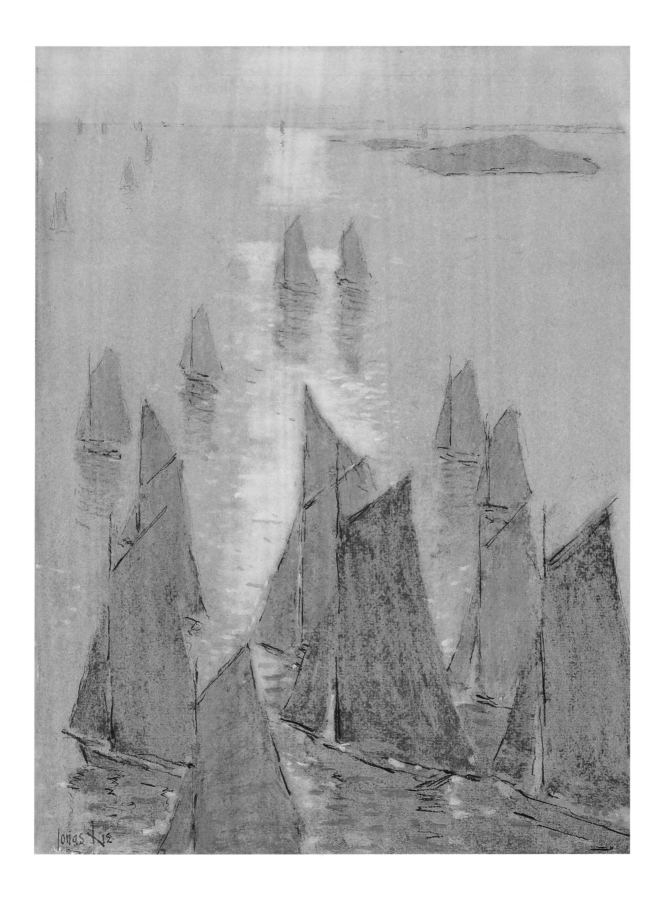

25.

Monhegan Island, Maine, ca. 1926–27
Oil on canvas
30 × 60 inches
Signed lower right: *Jonas Lie*

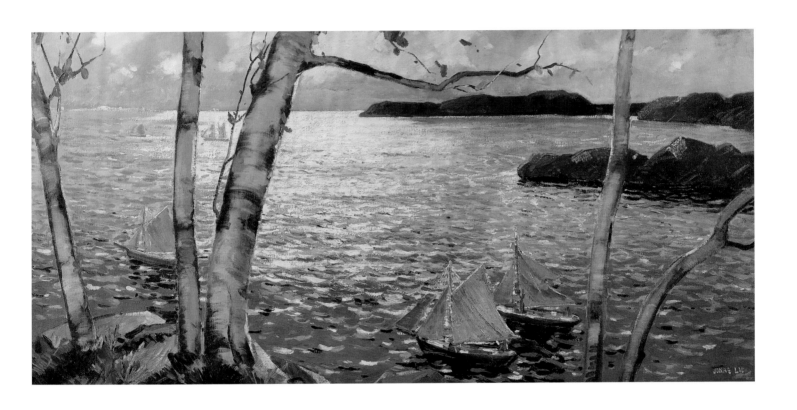

26.

The Fleet, ca. 1925
(Norway)
Oil on canvas
30 × 45 inches
Signed lower left: *Jonas Lie*

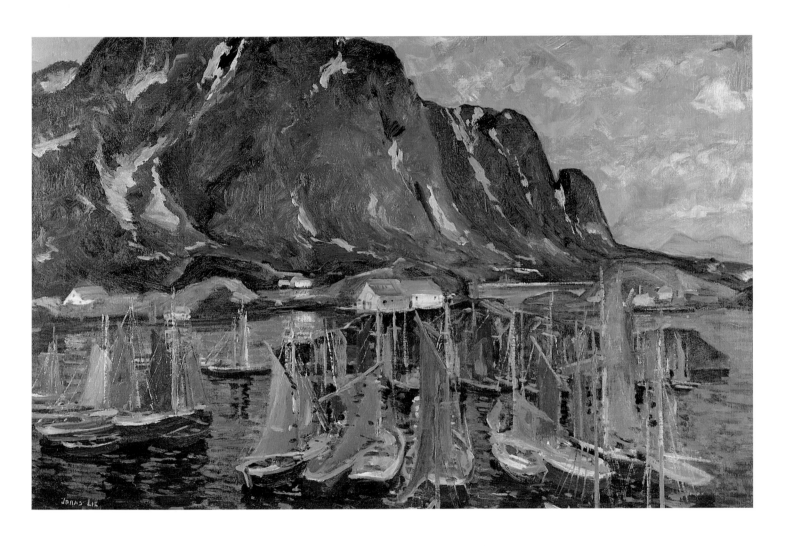

27.

Old Wharves, Camden, Maine, ca. 1925–40

Oil on canvas

25 × 36 inches

Signed lower left: *Jonas Lie*

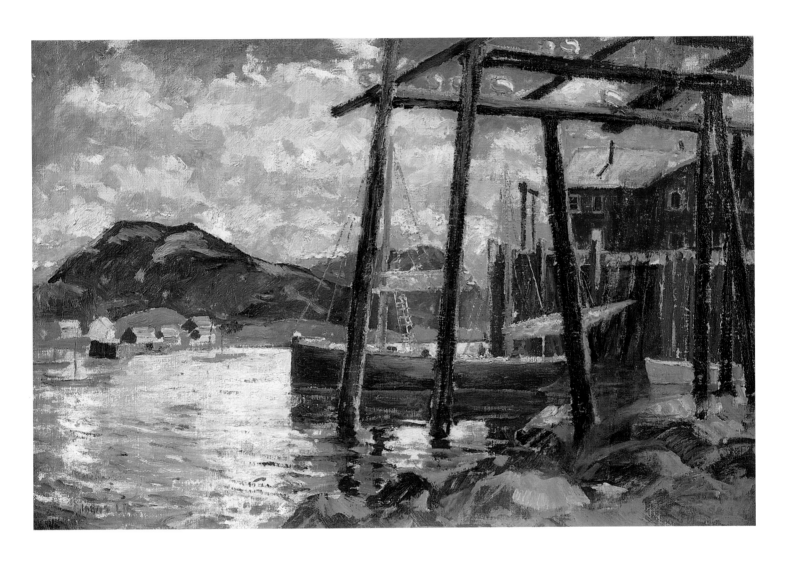

28.

The Road to the Chapel, Kamp Kill Kare, 1930
(Raquette Lake, Adirondack Mountains, New York)
Oil on canvas
28 × 24 inches
Signed lower left: *Jonas Lie*

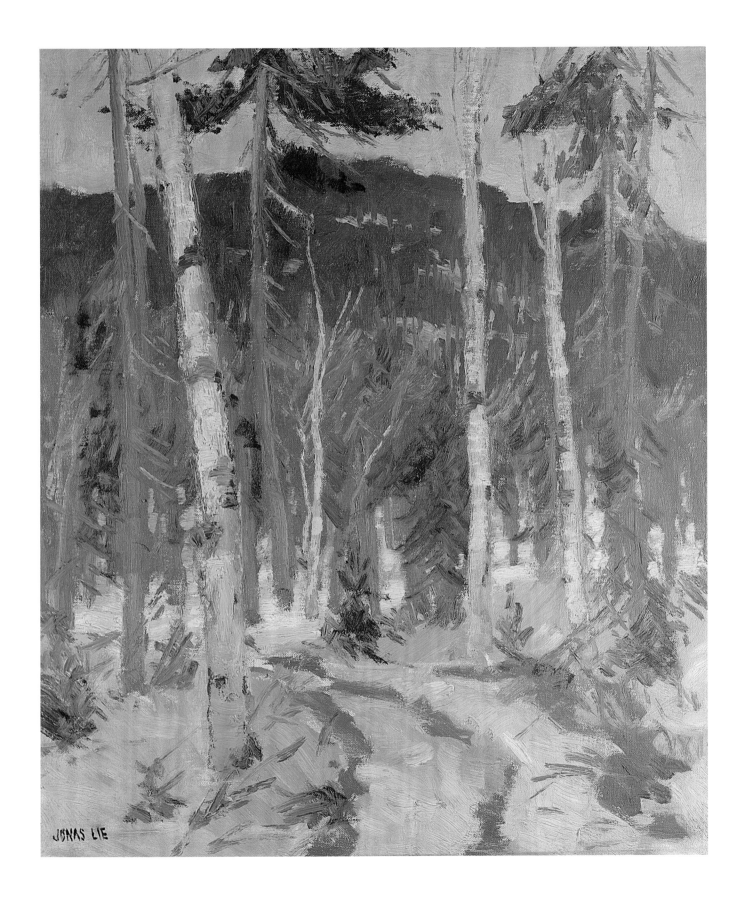

29.

The Chapel, Kamp Kill Kare, 1930
(Raquette Lake, Adirondack Mountains, New York)
Oil on canvas
29 × 39 inches
Signed lower left: *Jonas Lie*

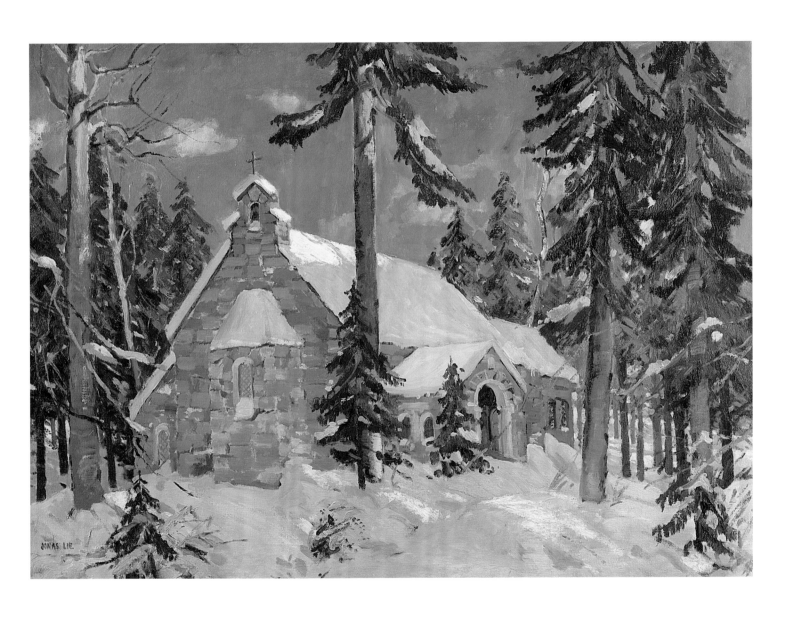

30.

Main Camp, Kamp Kill Kare,
Raquette Lake, February, 1930
Oil on canvas
40 × 50¼ inches
Signed lower left: *Jonas Lie*
Adirondack Museum, Blue Mountain Lake, New York
Gift of Beatrice W. Garvan in memory of
Anthony N. B. Garvan (1917–1992)

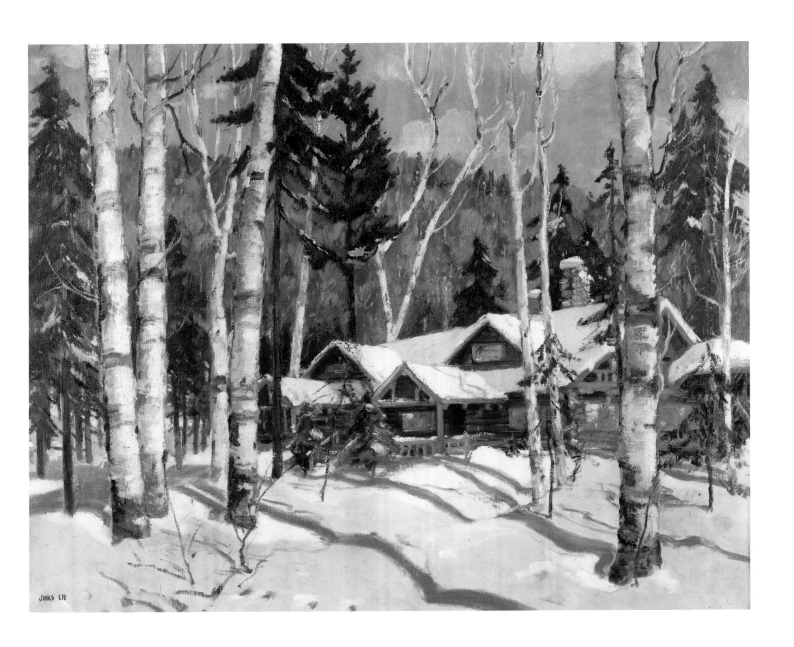

31.

The Inner Harbor, ca. 1933
(New England)
Oil on canvas
30 × 45 inches

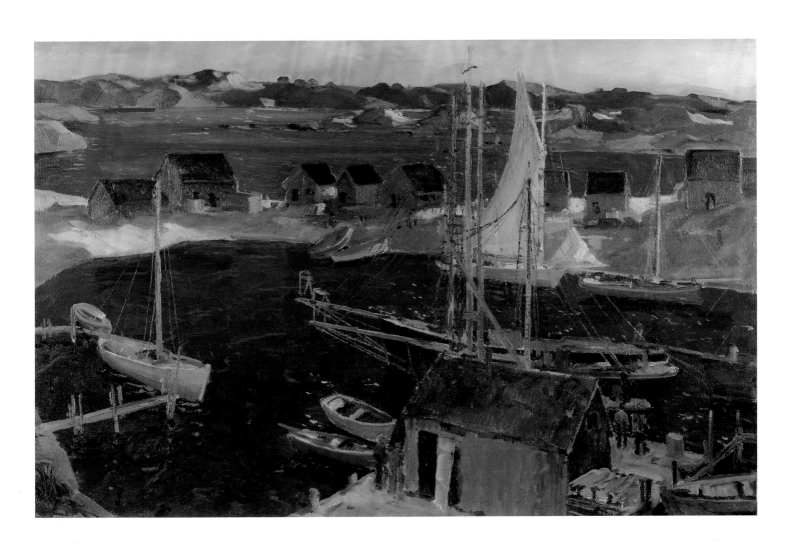

32.

Amber Light (Amberjack II), 1933
(Passamaquoddy Bay, New Brunswick, Canada)
Oil on canvas
30⅜ × 45¼ inches
Signed, dated, and inscribed lower left: *To Franklin D.*
Roosevelt / in friendship and admiration / from Jonas Lie. 1933

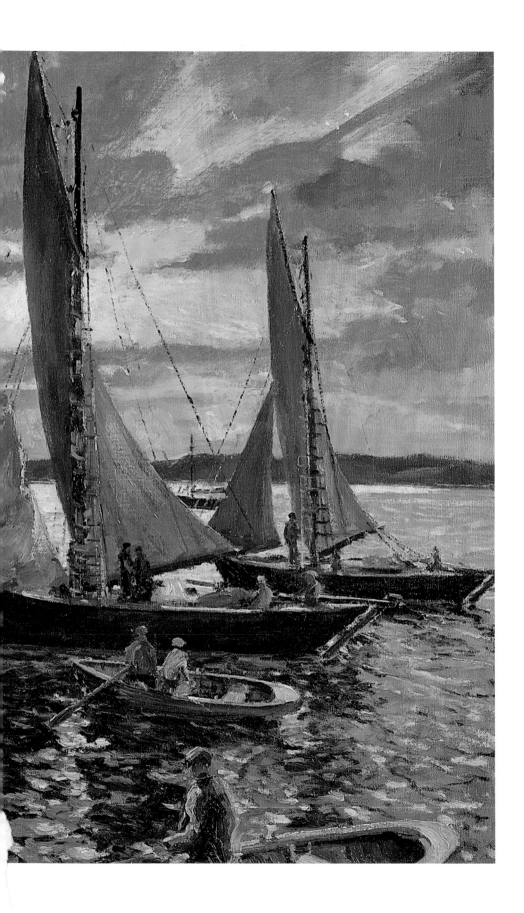

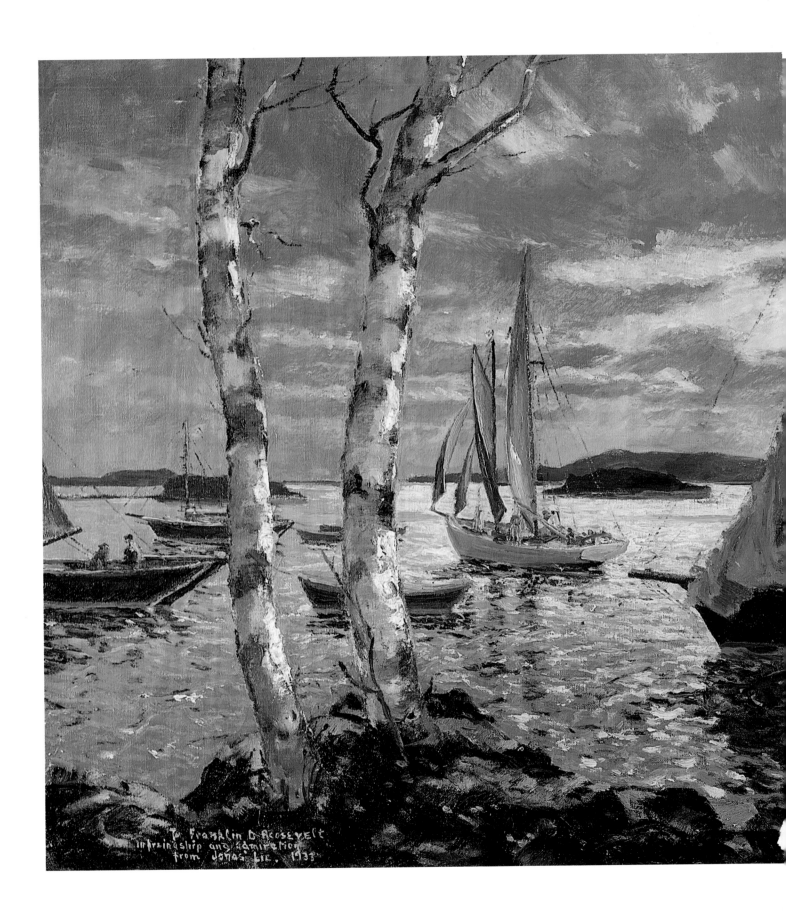

To Franklin D. Roosevelt
in friendship and admiration
from Jonas Lie. 1933

33.

Into the Sunset, ca. 1930
Oil on canvas
30 × 40 inches
Signed lower right: *Jonas Lie*

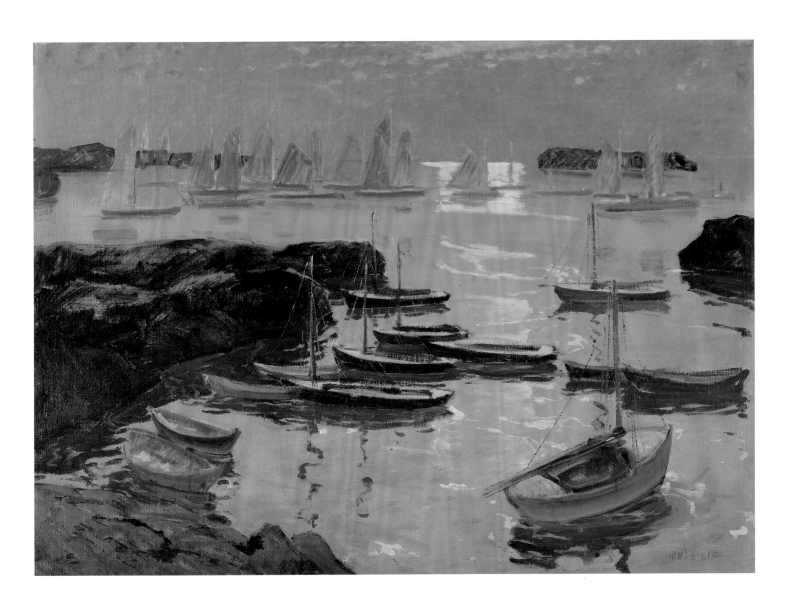

34.

Winter Landscape, 1936
(New York or New England)
Oil on canvas
29½ × 47½ inches
Signed and dated lower left: *Jonas Lie 1936*

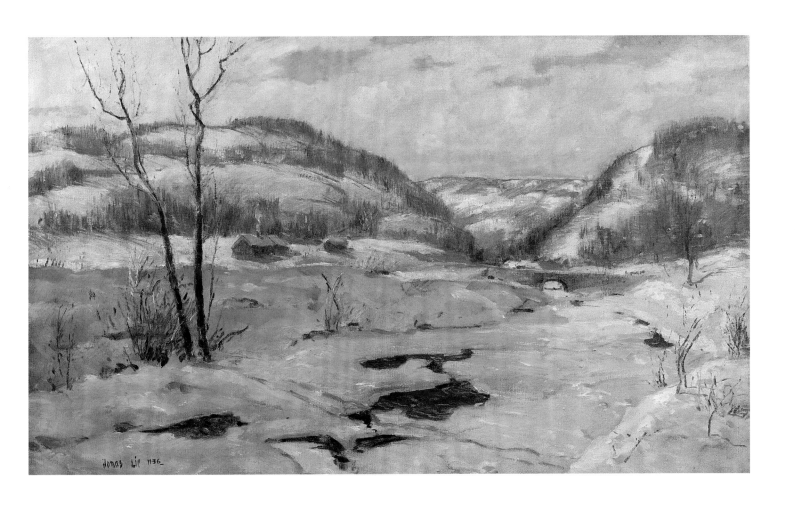

35.

Coming Home, 1936
Oil on canvas
22 × 33 inches
Signed lower left: *Jonas Lie P. N. A.*
[President National Academy]

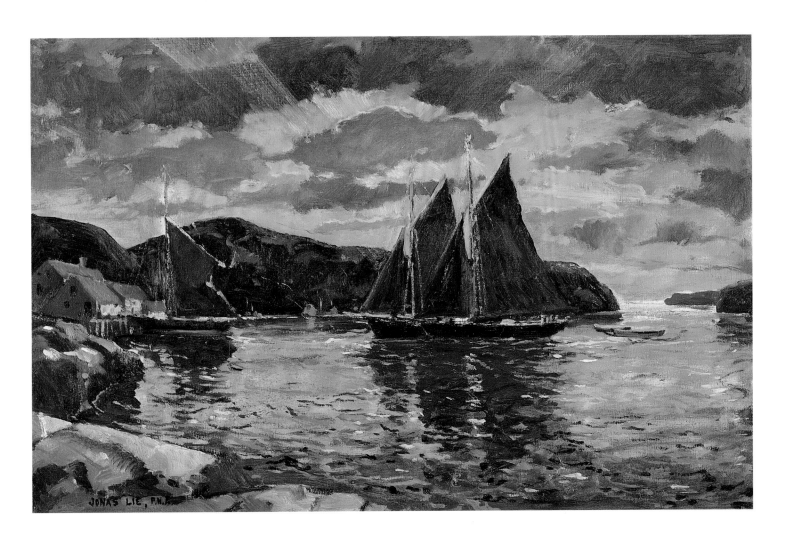

Chronology

CAROL LOWREY

Fig. 8. John Christian
Johansen, *Jonas Lie*,
1912, oil on canvas,
28¼ × 23⅛ in.,
National Academy
Museum, New York.

1880

Born 29 April in Moss, Norway, the only son and the third of four children of Sverre Lie, a Norwegian civil engineer, and his Connecticut-born wife Helen Augusta (Steele) Lie. Family moves to Christiania (now Oslo) when Lie is six months old. Several of his aunts were pianists and composers; visitors to the family household included pianist Edvard Grieg and playwright Henrik Ibsen. As a small boy, Lie demonstrates a strong interest in music; he takes up the piano at age six and is composing music and attending concerts by the age of nine.

1892

Spends three months in the studio of his cousin, the artist Christian Skredsvig, where he paints landscapes.

September—Lie's father dies while his mother and sisters are visiting America. Lie is sent to Paris to live with his uncle and namesake, the novelist, Jonas Lauritz Edemil Lie (1833–1908). Fraternizes with members of the Scandinavian colony in Paris, including Ibsen. Attends a French school during the day and studies drawing at a small private art school in the evenings.

1893

October—Lie joins his family in New York City, residing in his aunt's boarding house at 71 East 85th Street.

1893–97

Attends Felix Adler's Ethical Culture School (known at that time as the Workingman's School) in New York City on a scholarship. In the summer of 1896, in conjunction with his studies, he attends an outdoor painting class taught by Dewing Woodward in Provincetown, Massachusetts. Also takes night classes in life drawing at Woodward's studio.

1897

Graduates from the Ethical Culture School. Goes to work at Manchester Mills, a textile factory in New York City, where he makes designs for men's calico and gingham shirts.

ca. 1900

Lie is said to have attended free evening classes at the National Academy of Design, although his name does not appear in the student registers for the late 1890s and early 1900s. Attends winter classes at the Cooper Union School. Visits local exhibitions, including those of commercial galleries.

ca. 1900–06

Paints in New York City and in Ridgefield, New Jersey, with Van Dearing Perrine, Charles Hawthorne, Ernest Roth, and other members of the Country Sketch Club.

1901

January—Makes his debut at the National Academy of Design with *A Gray Day*. Exhibits there regularly until 1940.

March—Exhibits with the Country Sketch Club at the Art Institute of Chicago.

Moves to Plainfield, New Jersey.

1901–02

Attends classes at the Art Students League. En route to Manhattan from New Jersey, sketches from the Jersey City ferries.

1903

January–February—Lie's landscape, *A Winter Idyll*, is purchased by the painter William Merritt Chase from the annual exhibition of the Pennsylvania Academy of the Fine Arts. Chase buys a second painting by Lie from the twenty-fifth annual exhibition of the Society of American Artists.

1904

Takes a studio in the Babcock Building on Front Street in Plainfield.

Awarded a silver medal at the Louisiana Purchase Exposition in St. Louis for *Mill Race*.

1905

March—Solo exhibition, *Paintings by Jonas Lie*, held at the New Gallery, New York City.

December 1905–January 1906—Solo exhibition, *Paintings by Jonas Lie*, held at the Pratt Institute, Brooklyn.

1906

Loses his job at Manchester Mills when it is converted to a woolen shop. Visits Norway. Also goes to Paris, where he sees work by Claude Monet.

1907

September—Marries Charlotte Egede Nissen at All Souls Unitarian Church in Plainfield.

1907–08

Gives painting lessons in his Plainfield studio; his students include John Fulton Folinsbee.

1909–10

Spends eighteen months in Norway, with visits to Oslo and Lillehammer. Also makes a three-month trip to Paris in the spring of 1909, where he paints along the Seine and visits commercial galleries; sees and is impressed with the work of the Post-Impressionist painter, Paul Gauguin. Also attends the salon of Gertrude and Leo Stein and meets the Fauvist painter, Henri Matisse.

1910

Moves back to New York City, residing at 60 Washington Square. Begins to paint urban subjects.

1911

October—*Recent Portraits and Landscapes by Jonas Lie*, held at the Folsom Galleries, New York City.

December—Joins the Association of American Painters and Sculptors, which organized the Armory Show (*International Exhibition of Modern Art*); Lie serves on the Committee on Foreign Exhibits.

1912

Elected an associate member of the National Academy of Design (Fig. 8).

January—Solo exhibition, *Recent Works by Jonas Lie*, held at the Corcoran Gallery of Art, Washington, D.C.

January–February—Solo exhibition, *Exhibition of Paintings by Jonas Lie*, held at the John Herron Art Institute, Indianapolis.

March—*Exhibition of Paintings by Mr. Jonas Lie and Mrs. Leslie W. Lee,* held at the Milwaukee Art Society.

April—Solo exhibition, *Paintings by Jonas Lie,* held at the Toledo Museum of Art, Ohio.

July–September—Solo exhibition, *Exhibition of Paintings by Jonas Lie*, held at the Art Institute of Chicago.

December—*Pictures by Jonas Lie and John Wenger,* held at the Folsom Galleries, New York City.

1913

Early 1913—Spends three months at the Panama Canal. Paints a series of oils portraying aspects of its excavation and construction.

February–March—Exhibits *The Black Teapot, At the Aquarium, A Hill Top, The Quarry,* and *Street* at the Armory Show. One of his figural works, a depiction of Norwegian peasants dancing, is sold from the exhibition.

December—Solo exhibition, *Paintings of the Panama Canal by Jonas Lie*, held at M. Knoedler & Co. in New York City; purchases are made by the Metropolitan Museum of Art and the Detroit Museum of Art.

Takes a studio in the Holbein Studio Building at 154 West 55th Street, where he paints and teaches.

1914

Awarded the National Academy of Design's Julius Hallgarten Prize for *Afterglow*.

February—Twenty paintings from the Panama Canal series are featured at the annual exhibition of the Pennsylvania Academy of the Fine Arts, Philadelphia.

April–May—*Exhibition of Paintings by Jonas Lie of New York, Leopold Seyffert and Richard Blossom Farley of Philadelphia*, held at the Memorial Art Gallery, Rochester, New York.

Conducts a summer painting class at Port Jefferson, Long Island.

Exhibits Panama Canal series at the Art Institute of Chicago (July–September), the Albright Art Gallery, Buffalo, New York (October), and the Memorial Art Gallery, Rochester (November).

December—Solo exhibition, *Works by Jonas Lie,* held at the City Club, New York City.

1915

Awarded a silver medal at the Panama-Pacific International Exposition for *Gates of Pedro Miguel.*

March—Solo exhibition, *Oils by Jonas Lie*, held at the Pratt Institute.

March–April—Solo exhibition, *Works by Jonas Lie,* held at the Ralston Gallery, New York City.

1916

March—Divorces his first wife.

May—Solo exhibition, *Recent Paintings by Jonas Lie*, held at M. Knoedler & Co.

On 1 July, Lie marries Inga Sontum, a Norwegian-born ballet dancer. Following his honeymoon in Nova Scotia, he conducts a summer class in out-door painting in Woodstock, New York, as a favor to his former teacher, Dewing Woodward.

1917

January–February—Solo exhibition, *Recent Work by Jonas Lie*, held at the Montross Gallery, New York City.

March—Solo exhibition, *Paintings by Jonas Lie*, held at the Portland Museum of Art, Maine.

May—Solo exhibition, *Exhibition of Paintings by Jonas Lie*, held at the Museum of History, Science, and Art, Los Angeles.

Daughter Sonja is born.

Spends the summer in Carmel, California.

Travels to Utah; paints eight views of the Bingham Copper Mine, near Salt Lake City, for its vice-president, D. C. Jackling.

November–December—Exhibits his copper mine pictures at M. Knoedler & Co.

1918

January—Elected an artist life member of the National Arts Club, New York City.

June—Solo exhibition, *Exhibition of Paintings by Jonas Lie*, held at the Milwaukee Art Institute.

Takes a studio in the Sherwood Studio Building at 58 West 57th Street. Designs a poster, *On the Job for Victory*, for the United States Shipping Board Emergency Fleet Corporation.

1919

January–February—Solo exhibition, *Exhibition of Paintings by Jonas Lie*, held at the Art Institute of Chicago.

October–November—Solo exhibition, *Exhibition of Paintings by Jonas Lie*, held at the Carnegie Institute, Pittsburgh.

Autumn—Along with Robert Henri, George Bellows, John Sloan, and others, Lie establishes the American Painters, Sculptors and Gravers (renamed the New Society of Artists in 1920) in reaction to the conservative policies of the National Academy of Design.

Lie's *Ice Harvest* is acquired by the Luxembourg Museum, Paris.

1920

February—Solo exhibition, *Paintings by Jonas Lie*, held at the Maryland Institute Gallery, Baltimore.

April–May—Solo exhibition, *Paintings by Jonas Lie*, held at the Rhode Island School of Design, Providence.

October–November—Solo exhibition, *Collection of Oil Paintings by Jonas Lie*, held at the Memorial Art Gallery.

1921

February—Solo exhibition, *Paintings by Jonas Lie*, held at the Syracuse Museum of Fine Arts, Syracuse, New York.

March–April—Solo exhibition, *Paintings by Jonas Lie, A.N.A.,* held at the Macbeth Gallery, New York City.

October—Solo exhibition, *Paintings by Jonas Lie*, held at the City Club, New York City.

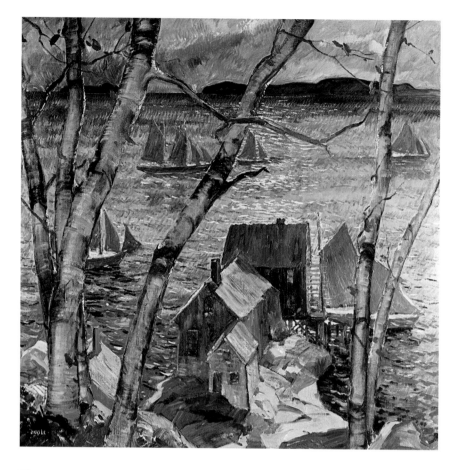

Fig. 9. Jonas Lie, *Herring Cove at Dawn*, photograph courtesy Peter A. Juley & Son Collection, Smithsonian American Art Museum, Washington, D.C.

1922

August—Purchases Howland Cottage at 135 Park Avenue in Saranac Lake, in the Adirondack Mountains of upstate New York. Spends several years there while Inga undergoes treatment for tuberculosis at the Trudeau Sanatarium. The town of Plainfield acquires *The Birches*.

1923

April—Solo exhibition, *Paintings by Jonas Lie*, held at Ainslee Galleries, New York City.

December—*Paintings by Jonas Lie and George de Forest Brush*, held at the Vandyke Gallery, Washington, D.C.

1924

March—Solo exhibition, *Group of Pictures by Jonas Lie*, held at the Vandyke Gallery.

October–November—*Exhibition of Landscapes by Jonas Lie and Carl Krafft,* held at the Memorial Art Gallery.

December—Solo exhibition, *Paintings by Jonas Lie,* held at the Robert Vose Gallery, Boston.

December 1924–January 1925—Solo exhibition, *Paintings by Jonas Lie*, held at New York Public Library.

1925

Sells his cottage at Saranac Lake, but continues to make painting trips to the Adirondack region. Elected an academician of the National Academy of Design. Awarded a gold medal of honor at Philadelphia Art Week and First Prize at the Norske Club, Chicago.

February—Solo exhibition held at Anderson Galleries, Chicago.

Spring–Summer—Visits Norway.

November—Solo exhibition, *Landscape Paintings Made in the Adirondacks and Norway by Jonas Lie*, held at Robert Vose Gallery.

1926

January–February—Solo exhibition, *Exhibition of Paintings by Jonas Lie, N.A.,* held at the Macbeth Gallery.

Spring/Summer—Visits Norway.

July—Inga Sontum dies in Oslo from tuberculosis.

1927

January—Solo exhibition, *Recent Paintings by Jonas Lie*, held at the Macbeth Gallery.

Awarded the Andrew Carnegie Prize at the National Academy of Design for *The Cloud*. Resides at 150 East 71st Street.

1928

Mr. and Mrs. Francis P. Garvan commission Lie to paint a series of oils depicting Kamp Kill Kare on Lake Kora in the Adirondack Mountains.

April—Solo exhibition, *Paintings by Jonas Lie*, held at the Robert Vose Gallery.

1929

January—Awarded the Maida Gregg Memorial Prize at the National Arts Club for *Herring Cove at Dawn* (Fig. 9), which was presented by a group of Norwegian-Americans to Crown Prince Olaf of Norway and Princess Martha of Sweden on the occasion of their marriage.

Visits Norway. Paints in the Brittany region of France.

The remaining works in Lie's Panama Canal series are purchased by an anonymous benefactor and presented to the U.S. Military Academy at West Point in memory of Colonel George W. Goethels of the U.S. Army Corps of Engineers.

Elected a member of the National Institute of Arts and Letters, New York City.

Late 1920s–1930s

Focuses on marine painting, drawing subject matter from coastal New England and the Canadian Maritimes.

1930

February—Spends the month at Kamp Kill Kare, where he paints a series of oils depicting camp buildings and the surrounding landscape.

October—Donates a mural painting to All Souls Church in Plainfield, as a tribute from Sonja to her mother, Inga.

1931

January—Solo exhibition, *Brittany & Other Recent Paintings*, held at the Macbeth Gallery.

1931–33

Serves on the Board of Control at the Art Students League.

1932

Appointed to the Art Commission of the City of New York. Appointed Knight of the Order of St. Olav by King Haakon VII of Norway. At the Art Students League, Lie opposes John Sloan's decision to invite the German artist, George Grosz, to teach there. Both Lie and Sloan resign over the dispute; Lie's resignation is not accepted by the board.

March–April—Solo exhibition, *Eleven Recent Paintings by Jonas Lie*, held at the Macbeth Gallery.

1934

March—Solo exhibition, *Paintings of Martha's Vineyard by Jonas Lie*, at the Macbeth Gallery.

Visits Norway.

1934–39

Serves as president of the National Academy of Design, the first non-American to hold that position. As a result of his liberal administration, which included reorganizing the jury of selection, the academy began to show work by more progressive, non-establishment artists, a number of whom, such as John Steuart Curry, Reginald Marsh, and Charles Prendergast, were elected into the ranks of the membership. Lie also appointed a group of liberal-minded artists to oversee the academy free art school, among them Gifford Beal, John Taylor Arms, and F. Luis Mora.

1935

Awarded the Jennie Sesnan Medal at the Pennsylvania Academy of the Fine Arts for *Snow*.

1936

Awarded the Saltus Award for Merit at the National Academy of Design for *The Curtain Rises*. Serves as vice-president, National Institute of Arts and Letters. Awarded Doctor of Fine Arts degree from Lawrence College, Appleton, Wisconsin. Along with the surgeon Alexis Carrell and the composer Walter Damrosch, Lie receives the first annual National Institute of Immigrant Welfare Award of Merit in recognition of his contributions to American life.

1937

Awarded the Adolph and Clara Obrig Prize at the National Academy of Design for *Rockbound Coast*.

Summer—Paints in Holland and on England's Cornish seacoast.

1938

Awarded the Prize for Marine Painting at the National Arts Club. Awarded the Saltus Medal for Merit at the National Academy of Design for *Old Smuggler's Cove*. Receives Doctor of Fine Arts degree from Syracuse University.

April–May—Solo exhibition at Grand Central Art Galleries, New York City.

1939

Summer—Paints in Maine and in Québec's Gaspé peninsula.

October—Resigns as president of the National Academy of Design due to ill health.

1940

10 January—Dies of pneumonia at Doctor's Hospital, New York City. Is buried at Hillside Cemetery, Plainfield, New Jersey.

May—A memorial exhibition of Lie's work is held at Grand Central Art Galleries.

1944

September—The U.S. Marine Commission launches the Liberty ship: *S.S. Jonas Lie*.

Selected Bibliography

Carol Lowrey

MANUSCRIPT AND ARCHIVAL SOURCES

Goldberg, Zehava. "Jonas Lie (1880–1940): When the Days Grow Longer, 1920." Typescript. Biography and catalogue entry, Sotheby's Works of Art Program, New York, 1986.

Lie, Jonas. Interview by DeWitt McClellan Lockman, 9 June 1927. DeWitt McClellan Lockman Papers, Archives of American Art, Smithsonian Institution, Washington, D.C., reel 503.

Macbeth Gallery. Papers. Archives of American Art, Smithsonian Institution, Washington, D.C., reel NMc59.

National Academy of Design, New York. Jonas Lie File.

Pasquine, Ruth. "Notes on Jonas Lie." Typescript, 1989. Photocopy, Artist's File, Spanierman Gallery, LLC, New York.

BOOKS, EXHIBITION CATALOGUES AND ARTICLES (IN CHRONOLOGICAL ORDER)

Caffin, Charles H. "Pennsylvania Academy Exhibition." *International Studio* 25 (March 1905): supp. iii.

[Huneker, James]. "Around the Galleries." *Sun* (New York), 7 January 1907, p. 6.

"Jonas Lie of Norway and America: A Painter Who Has Found the Secret of Suggesting on Canvas Nature's Manifold Moods." *Craftsman* 13 (November 1907): 135–39.

"Presentation of Jonas Lie's Development in Painting at the Folsom Galleries." *Craftsman* 21 (January 1912): 455.

"Norwegian Artist: Interpreter of America." *Current Literature* 52 (February 1912): 222–24.

Millard, Bailey. "The Painters of the Palisades." *Bookman* 35 (May 1912): 256–65.

What the Critics say about Jonas Lie's paintings of The Panama Canal. [1914?]. [A compilation of newspaper and magazine reviews by major critics such as Royal Cortissoz, Arthur Hoeber, Charles H. Caffin, William B. McCormick, Fullerton Waldo and others.]

"Exhibitions at the Galleries—Some More Pictures of the Canal." *Arts and Decoration* 4 (February 1914): 158–59.

N., W. H. [Nelson, W. H. de B.] "A Painter of Panama: Jonas Lie." *International Studio* 51 (February 1914): cxcii–civ.

Stuart, Evelyn Marie. "Exhibitions at the Art Institute, Chicago: Exhibition by Jonas Lie." *Fine Arts Journal* 31 (September 1914).

"Jonas Lie Paintings on Show." *New York Times*, 30 March 1915, p. 7.

Brinton, Christian. "Jonas Lie: A Study in Temperament." *American-Scandinavian Review* 3 (July–August 1915): 197–207.

"Artist Sues for Divorce." *New York Times*, 23 March 1916, p. 6.

"Jonas Lie's Paintings on View." *New York Times*, 19 May 1916, p. 10.

"Miss Inga Sontum a Bride." *New York Times*, 18 July 1916, p. 9.

"Art Notes: Interesting Work to be Seen at the Galleries." *New York Times*, 16 November 1917, p. 10.

"A Few November Exhibitions." *Art World* 3 (December 1917): 233–34.

Bryant, Lorinda Munson. *American Pictures and Their Painters.* New York: John Lane Company, 1917, 216–18.

Official Posters: United States Shipping Board Emergency Fleet Corporation: Book No. 1. Philadelphia: United States Shipping Board, 1918.

Breese, Jessie Martin. "Jonas Lie—His House and Others." *Country Life in America* 36 (July 1919): 55–57.

"Jonas Lie at the Carnegie Institute." *American Magazine of Art* 11 (November 1919): 32–33.

"A Patriot in Paint: Jonas Lie." *Arts and Decoration* 12 (December 1919): 91.

Roberts, Mary Fantin. "A Distinguished Group Exhibition." *Touchstone* 6 (January 1920): 200–206, 257.

"Four Artists." *New York Times*, 27 March 1921, p. 8.

Tennant, E. May. "Jonas Lie, Citizen-Artist." *Arts and Decoration* 15 (August 1921): 221.

Field, Hamilton Easter. "Comment on the Arts." *Arts* 1 (August–September 1921): 34, 36.

"Plainfield Buys by Subscription a $5,000 Work by Jonas Lie." *American Art News* 21 (10 February 1923): 1.

Cahill, Edgar. " Jonas Lie: Poet of Today." *Shadowland* 7 (February 1923): 11, 70.

"Jonas Lie." *New York Times*, 8 April 1923, p. 7.

Brinton, Christian. "Jonas Lie—An Interpretation." In *Paintings by Jonas Lie*. Exh. cat. New York: Ainslie Galleries, 1923.

"Rochester—Note re Exhibition of Landscapes and Harbor Scenes by Jonas Lie." *Art News* 23 (18 October 1924): 10.

Berry, Rose V. S. "Jonas Lie: The Man and His Art." *American Magazine of Art* 16 (February 1925): 59–66.

Philpott, A. J. "Paintings by Jonas Lie Regarded as Symphonies, Vibrant in Color." *Globe* (New York), 12 March 1925.

"Speaks on American Art at Dinner of National Association of Women Painters and Sculptors." *New York Times*, 16 April 1925, p. 10.

"Art: Exhibitions of the Week: Decorations from Sea and Forest." *New York Times*, 19 April 1925, sec. 9, p. 11.

Price, F[rederic] Newlin. "Jonas Lie, Painter of Light." *International Studio* 82 (November 1925): 102–107.

"Jonas Lie: Macbeth Galleries." *Art News* 24 (30 January 1926): 9.

"Tri-National Sculpture Exhibition . . . Notable Work at Other Galleries . . . From the North." *New York Times*, 7 February 1926, sec. 7, p. 14.

"Painter Off Today for Lonely North." *New York Times*, 25 April 1926, sec. E, p. 22.

"Jonas Lie Sails for Norway." *Art News* 24 (1 May 1926): 4.

"Mrs. Jonas Lie Dead." *New York Times*, 6 July 1926, p. 21.

Exhibition of Paintings by Jonas Lie, N.A. Exh. cat. New York: William Macbeth, Inc., 1926.

J., E. A. [Jewell, Edward Alden]. "Further Comment on Exhibitions: Off to Venice, By Way of Africa: A Picture Journey Conducted by Jonas Lie, Erick Berry, Maclet and Favai." *New York Times*, 1 January 1928, p. 13.

"Will Present Picture by Lie to Prince Olaf." *New York Times*, 7 March 1929, p. 16.

"Paintings of Panama Canal Given to Nation as Memorial to Gen. G. W. Goethals." *New York Times*, 7 April 1929, p. 4.

"Paintings to West Point." *New York Times*, 25 April 1929, p. 4.

"Paintings by Lie Gift to West Point." *Art News* 27 (4 May 1929): 7.

Flynn, Claire Wallace. "Jonas Lie." *Park Avenue Social Review* (July 1930).

"Jonas Lie Gives Mural to New Jersey Church; A Tribute to Plainfield Friends of His Youth." *New York Times*, 5 October 1930, sec. 2, p. 1.

"Jonas Lie Presents Mural to Church." *Art News* 29 (11 October 1930): 6.

"Jonas Lie: Macbeth Galleries." *Art News* 29 (10 January 1931): 10.

"Jonas Lie's Idea." *Art Digest* 5 (15 January 1931): 7.

H., R. G. "Comment on Current Exhibitions in New York," *New York Times*, 18 January 1931, p. 18.

"Jonas Lie at Macbeth's," *Brooklyn Daily Eagle*, 18 January 1931.

"On View in the New York Galleries." *Parnassus* 3 (January 1931): 5.

"One-Man Show by Jonas Lie." *New York Times*, 7 April 1932, p. 21.

"Sloan Quits in Row as Art League Head." *New York Times*, 9 April 1932, p. 17.

J., E. A. [Jewell, Edward Alden]. "Macbeth Gallery." *New York Times*, 10 April 1932, sec. 7, p. 10.

"Lie v. Sloan." *Time*, 18 April 1932, p. 35.

"Norway Honors Jonas Lie." *New York Times*, 11 October 1932, p. 24.

"A Painting for the President." *Art Digest* 8 (15 December 1933): 26.

Jewell, Edward Alden. "New Values Seen in Jonas Lie's Art." *New York Times*, 16 March 1934, p. 19.

"New York Criticism: Jonas Lie Astonishes Critics." *Art Digest* 8 (1 April 1934): 14.

"Jonas Lie Slated to Head Academy." *New York Times*, 20 April 1934, p. 24.

"Jonas Lie Heads Design Academy." *New York Times*, 26 April 1934, p. 25.

Beer, Richard. "As They Are: 'Time for Living.' " *Art News* 32 (28 April 1934): 11.

"Lie Heads Academy." *Art Digest* 8 (1 May 1934): 12.

"Lie Plans Changes in Academy Policy." *New York Times*, 10 May 1934, p. 19.

"Plea for Art Gifts by Museum Scored." *New York Times*, 14 June 1934, p. 25.

"Houston and Lie." *Art Digest* 8 (1 July 1934): 26.

"Lie Acts to Make Liberal Academy." *New York Times*, 17 September 1934, p. 19.

"Art: Jonas Lie Institutes a One-Man Academy Revolution." *Newsweek*, 20 October 1934, p. 28.

"Jonas Lie—Painter." *Index of Twentieth Century Artists* 1 (August 1934): 225–30.

"Propaganda in Art Denounced By Lie." *New York Times*, 15 February 1935, p. 22.

"Jonas Lie Elected Again." *New York Times*, 25 April 1935, p. 19.

"Portrait." *Art Digest* 10 (15 October 1935): 7.

"President of the National Academy." *Arts and Decoration* 43 (October 1935): 27.

"Carrel, Damrosch and Lie Honored." *New York Times*, 14 May 1936, p. 22.

"Lie Heads Design Academy." *New York Times*, 29 April 1937, p. 14.

"Academy Elects Ten New Members." *New York Times*, 13 November 1937, p. 36.

"Lie Exhibits His 'Light and Air' Paintings." *Art Digest* 12 (15 April 1938): 16.

Jewell, Edward Alden. "Art Shows Given by Lie and Miro." *New York Times*, 19 April 1938, p. 22.

"Other Shows: Jonas Lie." *New York Times*, 24 April 1938, sec. 10, p. 7.

"Academy Re-elects Jonas Lie." *New York Times*, 29 April 1938, p. 19.

Lie. Jonas. "Christmas Eve at Home." *Arts & Decoration* 49 (December 1938): 8–9, 40.

"Syracuse University Honors Lie." *Art Digest* 13 (July 1939): 7.

"Nichols Succeeds Lie as Head of Academy." *Art Digest* 14 (15 October 1939): 13.

Boswell, Peyton. *Modern American Painting* (Garden City, N.Y.: Garden City Publishing, 1939), 139–41.

"Jonas Lie is Dead; Noted Artist, 59." *New York Times*, 11 January 1940, p. 23.

"Jonas Lie Dies: Artist, Former Academy Head." *Herald-Tribune* (New York), 11 January 1940, p. 18.

Boswell, Peyton. "Comments: Jonas Lie." *Art Digest* 14 (15 January 1940): 3.

"Forum of Events: Deaths." *Architectural Forum* 72 (February 1940): 48.

"Jonas Lie." *Magazine of Art* 33 (February 1940): 119–20.

Woodward, Dewing. "The Readers Comment: He [*sic*] Knew Jonas Lie." *Art Digest* 14 (15 May 1940): 13.

"Jonas Lie Seen in Intimate Exhibition." *Art Digest* 14 (15 May 1940): 13

Jackman, Rilla. *American Arts*. Chicago: Rand McNally & Company, 1940, 286–89.

Cortissoz, Royal. "Jonas Lie," in *Commemorative Tributes of the American Academy of Arts and Letters, 1905–1942*. New York: American Academy of Arts and Letters, 1942, 397–99.

Bergmann, Leola Nelson, *Americans from Norway*. Philadelphia: J. B. Lippincott, 1950.

Clark, Eliot. *History of the National Academy of Design, 1825–1953*. New York: Columbia University Press, 1954.

Clark, Eliot C. "Lie, Jonas." *Dictionary of American Biography*, vol. 11, supp. 2 (1958), 384–85.

Masheck, Joseph. "The Panama Canal and Some Other Works of Work." *Artforum* 9 (May 1971): 38–41.

Garvan, Anthony N. B. *Adirondack Winter—1930: Paintings by Jonas Lie*. Exh. cat. Blue Mountain Lake, N.Y.: Adirondack Museum, 1971.

The Divided Heart: Scandinavian Immigrant Artists, 1850–1950. Exh. cat. Minneapolis: University Gallery, University of Minnesota, 1982.

Brown, Milton W. *The Story of the Armory Show*. New York: Abbeville Press, 1988.

Mandel, Patricia C. F. *Fair Wilderness: American Paintings in the Collections of the Adirondack Museum*. Exh. cat. Blue Mountain Lake, N.Y.: Adirondack Museum, 1990.

Davies, Kristian. *Artists of Cape Ann: A 150 Year Tradition*. Rockport, Mass.: Twin Lights Publishers, Inc., 2001, 86–87.

P[asquine], R[uth]. "Jonas Lie." In David B. Dearinger, gen. ed. *Paintings and Sculpture in the Collection of the National Academy of Design, Volume I, 1826–1925*. New York: Hudson Hills Press, 2004, 358–59.

Tolfsby, Dina. "Jonas Lie: Norwegian Silver in the American Melting Pot." In *Norwegian-American Essays 2004*. Oslo: NAHA—Norway, 2005, 282–308.

Index to Illustrations

Authors

WILLIAM H. GERDTS, professor emeritus of art history, Graduate School of the City University of New York; his writings encompass numerous articles and books, including *The Not-So-Still Life: A Century of California Painting and Sculpture* (with Susan Landauer and Patricia Trenton, 2003); *The Golden Age of American Impressionism* (with Carol Lowrey, 2003, Watson-Guptill); *Joseph Raphael (1869–1950): An Artistic Journey* (2003, Spanierman Gallery); *California Impressionism* (with Will South, 1998, Abbeville); *Impressionist New York* (1994, Abbeville); *William Glackens* (with Jorge H. Santis, 1996, Abbeville); *Monet's Giverny: An Impressionist Colony* (1993, Abbeville); *Art Across America* (1990, Abbeville); *American Impressionism* (1984, Abbeville); *Painters of the Humble Truth: Masterpieces of American Still-Life, 1801–1939* (1981, Philbrook Art Center); *Grand Illusions: History Painting in America* (with Mark Thistlewaite, 1988, Amon-Carter Museum); and *Down Garden Paths: The Floral Environment in American Art* (1983, Farleigh Dickinson University).

CAROL LOWREY, senior research consultant, Spanierman Gallery and curator of the permanent collection, National Arts Club in New York. A specialist in American and Canadian art of the late nineteenth and early twentieth centuries, she is the author of numerous articles, essays, and exhibition catalogues, including *The Golden Age of American Impressionism* (with William H. Gerdts, 2003, Watson-Guptill), *Richard Hayley Lever* (2003, Spanierman Gallery), *Canadian Impressionism* (1995, Americas Society), and *A Noble Tradition: American Paintings from the National Arts Club* (1995, Florence Griswold Museum).